BIRMINGHAM
LANDMARKS

BIRMINGHAM LANDMARKS

PEOPLE AND PLACES OF THE MAGIC CITY

VICTORIA G. MYERS

Charleston London

THE
History
PRESS

Published by The History Press
Charleston, SC 29403
www.historypress.net

Cover image: Vulcan statue. *Rob Lagerstrom, Vulcan Park and Museum.*

First published 2009

Manufactured in the United States

ISBN 978.1.59629.738.8

Library of Congress Cataloging-in-Publication Data

Myers, Victoria G.
Birmingham landmarks : people and places of the Magic City / Victoria G. Myers.
p. cm.
ISBN 978-1-59629-738-8
1. Birmingham (Ala.)--History. 2. Birmingham (Ala.)--Buildings, structures, etc. 3.
Historic buildings--Alabama--Birmingham. 4. Birmingham (Ala.)--Biography. I. Title.
F334.B68A25 2009
976.1'781--dc22
2009038613

CONTENTS

CONTENTS

ACKNOWLEDGEMENTS

A special thanks to those who helped check facts, answer questions or gather images to make this book a reality, especially:

Claire Vath, photo coordinator/photographer
Rachael Weekley, Sloss Furnaces
Karen R. Utz, Sloss Furnaces
David Brewer, Rickwood Fields
Audra Bean, Vulcan Park
John Bryan, great-grandson of Brother Bryan
Marilyn Raney, Ruffner Mountain Nature Center
Angela Fisher Hall, Civil Rights Institute
Jeff Ray, Barber Motorsports
Wayne Novy, Southern Museum of Flight
Bill Miller, Alabama Sports Hall of Fame
Carol Argo, the Samuel Ullman House
Greg Minisman, the Samuel Ullman House
Kenji Awakura, Good Ole Boys of Japan
Staff in the archives department of the Birmingham Public Library

INTRODUCTION

Threads of the Past

There is always a beginning. And in the case of Birmingham, Alabama, you can't truly understand or appreciate this living, pulsating, drawling, sophisticated, redneck, rock-strewn place without going back to that beginning. The measure of success here has always been the degree of unity. It's been through unity that the people have added beauty and softness to a scarred past.

"Unity" is an easy word to use but often a nearly impossible quality to attain. There are always opposing forces, those who believe their best interest is challenged by the unity of others. It is in conflict where they find political power or financial advantage. This fear of unity among the common man has a long history.

One of the best examples in Birmingham's past was the coal strike of 1908. This two-month-long labor dispute began bitter and became violent. What made it unique was the fact that the United Mine Workers Union (UMW), known locally as District 20, was interracial. District 20 was one of just a few labor organizations in Jim Crow Alabama that brought black and white workers together for a common cause. That unity was a real threat to wealthy industrial employers who dreamed of passing Pittsburgh as the nation's leading steel-producing city. They believed the key to reaching that mark would be low labor costs.

The preferred workforce in southern mines in the early 1900s was destitute black freedmen, impoverished whites and immigrants. Most workers never made more than two or three dollars per day. In 1903, Tennessee Coal, Iron

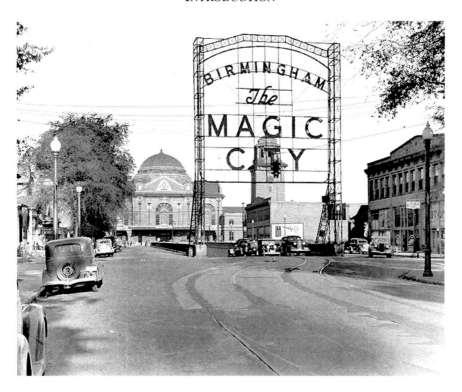

The original "Birmingham, the Magic City" sign was erected outside of the terminal station in 1926, where it stood for decades. *Vulcan Park and Museum.*

and Railroad (TCI) refused to renew the union's contract. By 1904, other mine employers were severing relations with the UMW, and a declaration was made that only nonunion workers would be hired.

In 1907, U.S. Steel bought TCI and wages began to slip. By 1908, many smaller mine operators had followed TCI's lead and cut pay, too. Finally, workers were forced to strike. On July 8, 1908, District 20 of the UMW went out. That first day four thousand walked off the job. By the end of the second week more locals had formed, and half of the twenty-thousand-man workforce was out.

As soon as workers seemed to be gaining an edge, armed confrontations began. The mine owners brought in strikebreakers from as far away as New York, and they increased use of nonpaid convict labor. They deputized hundreds of men to confront striking workers. Eventually, Governor Braxton Bragg Comer was convinced to send in state troops.

Looking back, what made this strike so threatening to those in power wasn't that the union wanted its members to make a better living. It was the fact that blacks and whites were marching in the streets together for a common

purpose. Tent cities sprang up for the unemployed, and whites and blacks lived in these transitory neighborhoods together. The mine owners recognized that unity between black and white workers could create a force that they might be unable to control. So they began to work to build up white vigilantism against the interracial UMW. This would be the key to breaking the union.

The business community was warned that the UMW's biracial organization would only ignite racial violence. The UMW was described as an insult to southern tradition. With that groundwork laid, a black UMW member, William Millin, was taken from a jail and lynched. The armed retaliation guaranteed that the governor would send in troops. Those troops cut down the tents in which strikers were living, and four days later union officials declared the strike over.

This is a powerful, but not altogether unusual, example of how the working man in the South has been treated like a puppet on a string over the decades by those who recognized, and feared, the power of unity. That fear, and the need to manipulate others in the community, still exists today, but more and more often it is recognized for the power grab it is. As issues take on racial overtones, people have begun to question who stands to lose power, or money, if unity is allowed to follow its natural course.

Today in Birmingham, people of all races and backgrounds work together to better the city and build that sense of unity. The ideal of unity here even has its own credo, "the Birmingham Pledge." Authored in 1998 by Birmingham attorney James Rotch, the pledge was initially promoted by the community affairs committee of Operation New Birmingham, a biracial group of civic leaders. Today the Birmingham Pledge Foundation is a grass-roots organization that works with others to spread the principles of the pledge. In 2000, Congress recognized the pledge, and in 2001 then President George W. Bush declared the week of September 15 "National Birmingham Pledge Week." The pledge, which can be signed online at www.birminghampledge.org, aims to eliminate racial prejudice one person at a time. It's a sign that unity in the Magic City exists today and can grow for a better tomorrow:

The Birmingham Pledge

I believe that every person has worth as an individual.
I believe that every person is entitled to dignity and respect, regardless of race or color.
I believe that every thought and every act of racial prejudice is harmful; if it is my thought or act, then it is harmful to me as well as to others.

Therefore, from this day forward I will strive daily to eliminate racial prejudice from my thoughts and actions.
I will discourage racial prejudice by others at every opportunity.
I will treat all people with dignity and respect; and I will strive daily to honor this pledge, knowing that the world will be a better place because of my effort.

As you read through *Birmingham Landmarks*, I hope you'll take the time to learn about and visit those places that have helped create this city. Many will elicit emotions and a deeper understanding if you can put your feet where others once walked. Can you imagine, for example, sending your children to march through downtown Birmingham in a civic protest? Have you ever conceived it possible that a bomb might explode in your church one Sunday morning? Faced with snarling dogs and fire hoses with enough pressure to tear your clothes off, would you be willing to withstand them?

Other parts of this book will hopefully inspire, making it clear how much one person can accomplish: a poem that helped a nation rebuild after World War II; or a man, some say a saint, who helped everyone he met and let the angels keep track of his good deeds because he didn't have the time. There are ghosts to think about, as well as the huge, ill-proportioned god of the forge, known around here simply as *Vulcan*. There are airplanes, motorcycles and sports heroes.

Taken separately, they may all seem a little disjointed. What, after all, does an antebellum mansion have to do with a baseball field or an airplane? But there is that thread of unity. It runs through them all, tying them all up into this place called magic—this place called Birmingham.

Chapter 1

UNIQUELY SOUTHERN

B eing southern isn't just about hoop skirts and big, white antebellum mansions—although that is certainly part of the charm for many. At its true heart, being southern is about feeling a sense of responsibility for that place that means home, whatever the neighborhood and whoever the neighbors.

It's a Jewish man who betters his community through charitable works and faith and fights to improve the educational system at a time when it was not the popular stand to take. It's a Presbyterian minister who takes his church to the streets, telling people that there is a better way while ladling out soup to the hungry or putting his coat over the shoulders of a homeless man.

Through wars, cholera outbreaks, flu epidemics and deep economic depressions, a young Birmingham survived because of the people who claimed it as their own. From the ten original founders to the chaplain of the city, there were people along the way who cared about the future of this Pittsburgh of the South. They are all responsible in some part both for what Birmingham was during their time and for what it became.

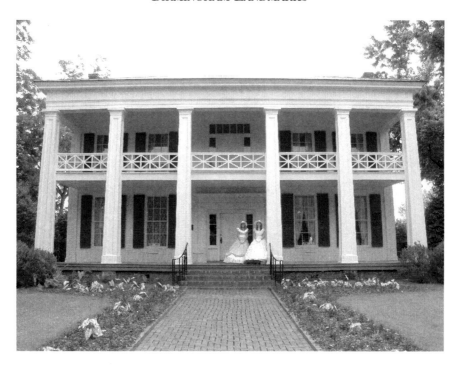

Arlington Antebellum Home and Gardens takes visitors back to the feel of the old southern plantation, complete with southern belles. *Victoria G. Myers.*

ARLINGTON ANTEBELLUM HOME AND GARDENS

There's no structure in Birmingham more closely rooted in the birth of this city than the beautifully restored antebellum mansion known as Arlington. The home was built for one of the ten founders of the city, Judge William S. Mudd.

Arlington wasn't always a mansion. It started out as a four-room, two-story farmhouse on 475 acres. The land was originally located in the corporate limits of Elyton. Stephen Hall built the original structure, which stayed in the family until his son, Samuel, was forced to sell the home and its grounds at auction in 1842. Mudd purchased the estate and went to work enlarging the structure with slave labor.

Four rooms became eight large rooms. A two-story gallery was added, as were six square columns across the front. The front entry was turned to the north. Two chimneys were added on the east side to mirror two on the west side. When all the work was done, Mudd proudly dubbed the house

Uniquely Southern

Well-manicured footpaths and outbuildings give visitors a feel for the southern landscape.
Claire Vath.

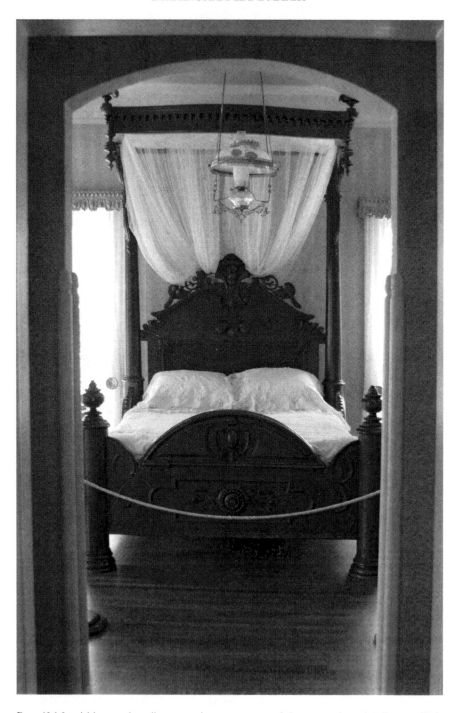

Beautiful furnishings and textiles are an important part of the restoration of Arlington. This is one of the master bedrooms. *Claire Vath.*

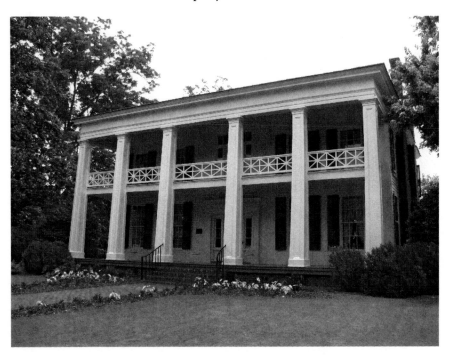

Arlington was purchased and enlarged by one of Birmingham's founders, Judge William S. Mudd. It was added to the National Register of Historic Places in 1970. *Victoria G. Myers.*

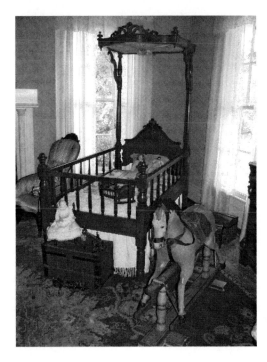

A nursery in the home includes antique toys and bedding. *Victoria G. Myers.*

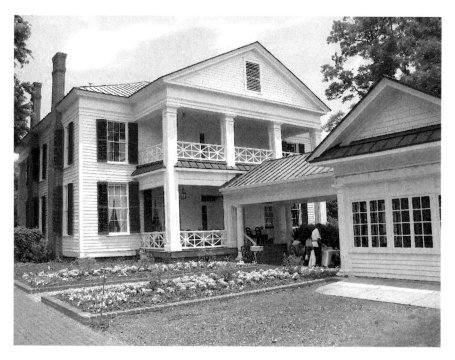

During the summer months, lunch is served on the back porch one day per week. *Victoria G. Myers.*

Arlington. Historians think that the name was a nod to General Robert E. Lee's Arlington House in Virginia.

Judge Mudd, as he was known until his death, did not actually become a judge until 1865, when he was elected circuit judge. He held that position until poor health forced him to retire in 1883. He died a year later in 1884. Prior to being a judge, Mudd was a lawyer and a member of the Alabama legislature. He was involved in business ventures all around the new city. He built Birmingham's first hotel, was involved in the operation of the Oxmoor Furnace and helped establish the Citizen's Bank. Mudd was married to Florence Jane Earle. The two had ten children, six boys and four girls.

Surviving the Civil War

The fact that Arlington stands today likely had a great deal to do with Mudd's cooperation with Federal authorities during the Civil War. Southern mansions like Arlington were routinely burned by Union troops, but this one served as a temporary headquarters for Major General James Wilson during

the spring of 1865. A graduate of West Point, Wilson had climbed through the ranks of the Union army and at twenty-eight was the youngest general. He was one of the "boy generals" and was considered by many to be the most successful of this lot. Wilson marched through Georgia and Alabama and led a large contingent of men, about 13,500 in three divisions.

While at Arlington it's thought that Wilson laid plans for General John T. Croxton to move on the town of Tuscaloosa. This would be a fateful blow to the Confederacy. Croxton's 1,500 troops seized Tuscaloosa, effectively shutting down one of the Confederacy's last centers for munitions and supplies. They also burnt most of the University of Alabama, which was known to have trained cadets for the Confederacy and operated a hospital for soldiers.

After the Civil War, Birmingham got back to business pretty quickly. It was 1871, and the Elyton Land Company was poised to build a city. Mudd's Arlington was initially located in the small town of Elyton, which in 1821 had just 300 residents. By 1871, the population there had grown to 1,100. Elyton was the county seat, and many of its citizens found work building the new city of Birmingham.

Building Birmingham

The city of Birmingham was the brainchild of a select group of community leaders who decided to form a company to make their idea of a city a reality. The city was to be named after England's iron-making city of Birmingham, a town that Josiah Morris had visited and obviously been impressed by.

The founders officially formed a company in January 1871 and named it the Elyton Land Company after the town in which they lived. The purpose of the company was to purchase land for the development of Birmingham. The initial shareholders, a group of ten men, raised $200,000. Today these ten are considered Birmingham's founders. The names of these shareholders and the number of shares they held were recorded in a history of Elyton: Josiah Morris (437 shares), James Powell (360 shares), Samuel Tate (360 shares), William Mudd (180 shares), William Nabers (180 shares), Benjamin Worthington (133 shares), Henry Caldwell (120 shares), James Gilmer (120 shares), Bolling Hall (120 shares) and Campbell Wallace (120 shares).

With the capital from these initial shareholders, planners began to plat streets and divide and sell lots. The center of town was established, and sites were set up for churches and parks. A hotel, the Relay House, was

built adjacent to the railroad. Birmingham Water Works was created. By 1873, some four thousand people had moved into cabins in the new city. The county seat was moved from Elyton to Birmingham. Conditions were perfect for the birth of the city. There was a real estate boom going on, and Elyton Land Company was selling property every day, several times a day, at sizeable profits. But it all ground to a sudden, heartbreaking stop with a cholera epidemic that started in 1873.

Problems with clean drinking water and poorly treated sewage among 4,000 people led to the cholera outbreaks. The epidemic started in June, and by the end of the summer 128 people had died from the disease. At the time it was unknown what caused cholera, so barrels of burning tar were put in the streets to help cleanse the air. It was thought that the disease was airborne. The population dropped by about half, as people left out of fear of cholera or out of desperation for work. The land speculators, holding unimproved property in a city where people were leaving in droves, were left with no way to pay for the property. Elyton Land Company was left holding property for which there was no longer a market. Elyton ended up taking some property back.

Jobs continued to dry up as the young city suffered severe repercussions from the nationwide stock market depression. This depression hurt Elyton Land Company, and its stock price plummeted as its debt increased. In 1876, the board of directors met to discuss the sale of all assets and bankruptcy. But as luck would have it, at this very same time Birmingham was on the verge of learning how to turn its unique and vast natural resources into a valuable enterprise.

Discovering Ironmaking

While Elyton Land Company could be credited with the creation of Birmingham, a man by the name of Levin Goodrich could be credited with saving it and putting it on the road to becoming the "Pittsburgh of the South," as it was later known.

Birmingham was a city rich in natural resources, having the three things needed to make iron in proximity to one another more so than at any other place known in the world. But technology had not yet reached the point at which it was understood that red ore could be used as cheaply and productively as brown ore in the iron-making process. Goodrich developed a coke pig iron production process and held the post as superintendent of the Experimental Coke and Iron Company. When Goodrich proved that the energy-efficient

process he developed would work, hope for the city began to recover. The Elyton Land Company's board decided to stick it out just a little longer and see if this new business endeavor would set the city back on the path of growth. The company donated land for what would become the Pratt Coal and Coke Company to Goodrich and partners James Sloss and Henry DeBardeleben. Some would say that aside from the initial purchase of land for the city, this one donation of property was the biggest contribution Elyton made to the future of Birmingham. It was the first of many land donations Elyton made to those in the community in a position to build industry.

The strategy was a wise one. In Elyton Land Company's annual meeting of stockholders in 1886, the president, Henry Caldwell, reported the following:

> ...while the demand for property in Birmingham has been dull, there has been no decline in values, but a steady increase. Birmingham has suffered less from the financial depression than almost any city in the country... This condition of things has doubtless been due in some measure to the policy pursued by the Elyton Land Company in pushing work during the dull times upon the various improvements inaugurated by it. The work done by your company during the past summer has tended greatly to inspire confidence, and the money spent has enabled many a working man to bridge over the most trying period.

Preserving the Past

After Judge Mudd's death in 1884, Arlington was sold to Henry Debardeleben. Without ever moving in, he resold the house to F.H. Whitney, who used it as a boardinghouse. In 1902, Arlington changed hands again, this time to Robert Munger. Munger owned Continental Gin Company, which had a manufacturing plant for cotton gins in Avondale. The home stayed in the Munger family until 1953, when the City of Birmingham bought it from Alex and Ruby Munger Montgomery for $53,000.

Arlington was purchased for the sole purpose of being furnished as a historical monument. The Arlington Historical Association restored the home as a monument to Birmingham's past and its founders. The house has an extensive collection of nineteenth-century furnishings, textiles, artwork and silver. It was added to the National Register of Historic Places in 1970. Visitors can come to tour the home and, during the summer, eat lunch in the garden area. Private and club events are also held at this spot.

Arlington Antebellum Home and Gardens is located at 331 Cotton Avenue SW on six acres. Arlington was initially a farmhouse; Judge William S. Mudd turned it into a mansion in 1842. Union forces stayed at the home during the Civil War. The home was added to the National Register of Historic Places in 1970. Arlington is open for tours. Go to www.informationbirmingham.com for current times and prices. During the summer months, lunch is served, by reservation only. Call 205-780-5656.

THE SAMUEL ULLMAN MUSEUM

Samuel Ullman is probably one of the most widely quoted American poets you've never heard of, unless you live in Japan. There he has reached a level of acclaim and affection he would have probably found hard to fathom, although he, no doubt, would have been pleased by it.

Even beyond a lifetime spent reaching out to build a better community around him, an argument could be made that Ullman owes his fame to the simple, little *Reader's Digest* magazine. Ullman had a rare history of civic

The Samuel Ullman Museum is the home in which Ullman lived for the last twenty years of his life. He moved into the home in 1907. *The Samuel Ullman Museum.*

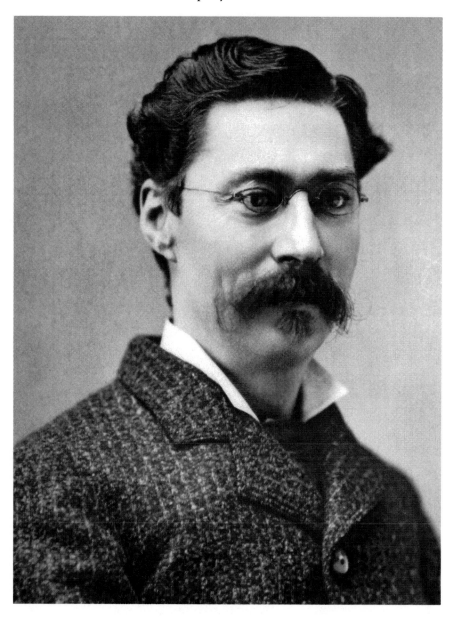

Samuel Ullman once said that he believed Judaism helped him become a Democrat, a "full-sized American." *The Samuel Ullman Museum.*

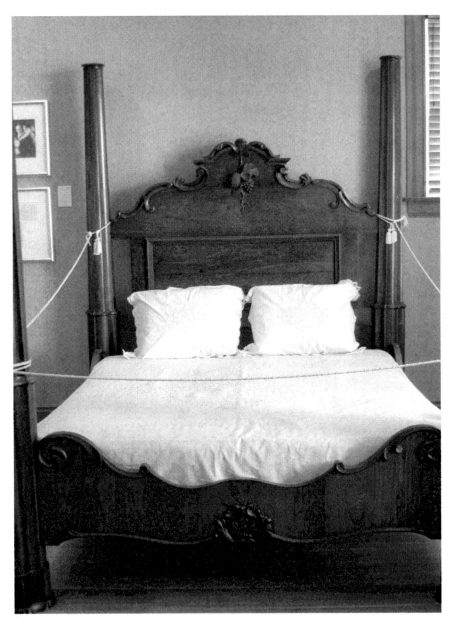

One of the most prized pieces in the Samuel Ullman Museum is a rosewood bed that he had crafted as a wedding gift for his wife in 1867. *Claire Vath.*

Ullman's old home is full of family photos and memorabilia, including several translations of his famous poetic essay "Youth." *Claire Vath.*

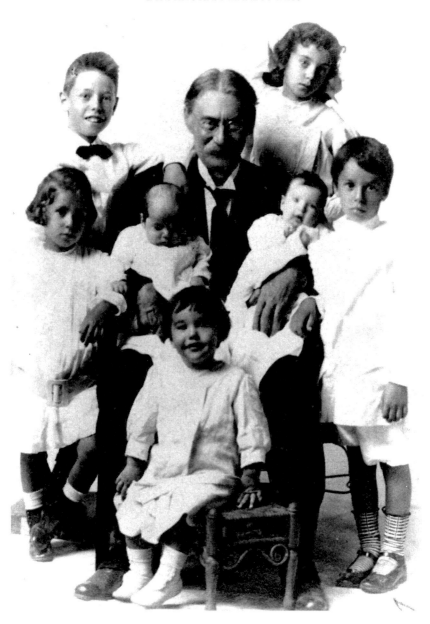

Samuel Ullman was seventy-eight when he wrote "Youth." Here he is in a favorite photo, posing with his many grandchildren. *The Samuel Ullman Museum.*

Tours of the Samuel Ullman Museum are available through the University of Alabama. *Claire Vath.*

involvement, leadership in reform Judaism in the Deep South and decades of work promoting education for all those attending public schools. But it was in the pages of that popular monthly compilation of abridged articles, funny stories and jokes that a poetic essay by Ullman was first published in December 1945. As often happens when words touch people, the message was embraced, but the creator was largely forgotten.

That poetic essay, entitled "Youth," began to gain its following when word got out that General Douglas MacArthur had a copy of the poem framed in his Tokyo office while he served as supreme allied commander following World War II. Japanese businessman Yasuzaemon Matsunaga translated "Youth" and began to share it with friends and colleagues. His skillful translation has long been considered part of the reason the poem reached so many throughout that country. The essay seemed to express the way a generation of Japanese felt as they rebuilt their country and looked for inner strength and the conviction to carry on in difficult times. But for many years, the author of "Youth" was unknown and was referred to simply as the "Phantom Poet."

Over the years, "Youth" was reproduced in a number of places, including the *Washington Post*, the *New York Times*, the Ann Landers column and the Dear Abby column. It has been referred to on national news shows by anchors who incorrectly attributed it to William Wordsworth. Parts of the poem were even used in a speech by then senator Robert F. Kennedy entitled "Day of Affirmation," delivered at the University of Cape Town, South Africa, in June 1966.

A Life of Service

A brief look back at Ullman's life shows that while his poetry would one day speak to the hearts of nations, his day-to-day life was focused on living out his moral and Judaic convictions in a pragmatic way in Birmingham, Alabama.

Ullman spent most of his young years in Port Gibson, Mississippi, where his German parents lived after immigrating to the United States. Ullman's father, Jacob, had a brother, Isaac, living in Port Gibson at the time. The family business was butchering. At the age of sixteen, young Samuel was sent to Louisville, Kentucky, to attend school. He returned to Port Gibson to help in the family business. At the age of twenty-one, in 1861, Ullman entered the Civil War as a private. He served the Confederacy and was injured twice in battle, losing much of his hearing in the war. He was discharged in November 1862.

After the Civil War ended, Ullman moved from Port Gibson to Natchez. There, in 1865, he and other reform-minded Jews in the area organized a nonorthodox temple, called Temple B'hai Israel. Many historians believe that this temple, and Ullman's dedication to his faith, helped set his character and put his feet on a path that would lead to reform. B'hai Israel was also where he met his beloved wife Emma, for whom he wrote many poems. They were married in May 1867. Samuel and Emma had eight children—six surviving into adulthood. There is evidence, in Ullman's own words, of how significant a role Judaism played in how he lived his life. At one time a lay rabbi, his words describing what it meant to him to be Hebrew, or Jewish, can now be seen in the context of a life lived in service to those around him:

> *This is Judaism, my friends. This is our religion. Need we be ashamed of it? Shall we be afraid of professing it, of acknowledging that we are proud of being Jews? Look around you. Compare and investigate and you will not discover any religion more simple or elevating. This is our pride, our joy, and glory. Away then with all cowardice. Away with indifference.*

Ullman would add that Judaism helped him become a democrat, a "full-sized American." He said that he believed in love, justice and liberty for all people and felt that part of his mission in life was to spread those tenets throughout all of society.

It was this belief system that Ullman brought with him to Birmingham when the family moved there in 1884. Ullman returned to the merchant's life, opening Ullman Hardware Company. His community involvements were far reaching. He was on the board of directors of the Birmingham

National Bank, and he incorporated and was president of the Lakeside Land Company. Despite these business involvements, Ullman was never the kind of businessman who really thrived financially. It might have been because business came after family, faith and people.

Ullman's move into the role of activist didn't seem overt, or even planned, for that matter. He was appointed a member of the city's first board of education, overseeing the public school system. He became controversial for promoting the idea that blacks needed better academic and vocational opportunities in their schools, which at the time were segregated from white public schools. In 1900, when he fought for a high school–level education in the black public schools, he pointed out that "schools can be maintained cheaper than penal institutions. An educated heart and hand is better adapted to overcome vice than simply so-called book learning." He would persuade the board to back the higher level of schooling, but he would also lose his place on the board for a short time because of it.

While Ullman's motivation seems to have been nothing more complex than doing what he felt was right at the time, he was running counter to racial bias that wanted to maintain the status quo. Political forces and prejudice were likely behind his dismissal from the board of education. Many in power at that time were trying to discourage blacks from voting, and that meant discouraging literacy and not promoting higher education. Looking back, though, Ullman's insistence on higher educational opportunities put Birmingham well ahead of surrounding states. It would be sixteen more years before Georgia, Mississippi, South Carolina or Louisiana began to have black public high schools.

In the Jewish community, Ullman's service was just as groundbreaking. He served as lay rabbi at Birmingham's Temple Emanu-El until 1894. His move from being a lay president of the community to lay rabbi was said to be unprecedented. He and wife Emma were strong community workers, helping create Hillman Hospital, a charity organization. Both served on the hospital's board of managers. Emma died unexpectedly after an illness in 1896. It was a dark, devastating period in Ullman's life. He never remarried. His many poems about Emma make clear his devotion to her.

After Ullman left his post as lay rabbi, he became an agent for New York Life Insurance Company, where he stayed until 1908. He continued to work on the board of education and was involved in the state's political issues. After Emma's death, daughter Leah took over many of her mother's responsibilities managing the house. In 1906, Leah married Morris Newfield, and Ullman began living with the couple at 2150 Fifteenth Avenue South until his death on March 21, 1924.

Much of Ullman's writing took place during these later years. His creative energy was focused on all sorts of writing. He wrote letters to editors of newspapers, letters to friends, essays and poetry. Ullman's love of writing was well known within the family. His nephew, Laurens Block, a founder of Birmingham's department store chain Parisian, encouraged his uncle, giving him a desk and hiring a secretary to take dictation and type. By most accounts "Youth" was written about 1918, when Ullman was seventy-eight.

On Ullman's eightieth birthday, his family celebrated by publishing a compilation of his poetic works entitled *From the Summit of Years, Four Score*. Friend John Herbert Phillips wrote a long letter honoring Ullman, in which he describes him as having "a noble spirit of optimism, self-sacrifice and sympathetic devotion for the highest ideals of truth and justice." Those words seem by all accounts to accurately describe the man's life and character. In fact, to all who knew him, Ullman seemed to have truly lived out the words of his poem. He did indeed "die young," but young at age eighty-four, not at eighty as the poem says.

"Youth"

Youth is not a time of life; it is a state of mind; it is not a matter of rosy cheeks, red lips and supple knees; it is a matter of the will, a quality of the imagination, a vigor of the emotions; it is the freshness of the deep springs of life.

Youth means a temperamental predominance of courage over timidity of the appetite, for adventure over the love of ease. This often exists in a man of sixty more than a boy of twenty. Nobody grows old merely by a number of years. We grow old by deserting our ideals.

Years may wrinkle the skin, but to give up enthusiasm wrinkles the soul. Worry, fear, self-distrust bows the heart and turns the spirit back to dust.

Whether sixty or sixteen, there is in every human being's heart the lure of wonder, the unfailing child-like appetite of what's next, and the joy of the game of living. In the center of your heart and my heart there is a wireless station, so long as it receives messages of beauty, hope, cheer, courage and power from men and from the Infinite, so long are you young.

When the aerials are down, and your spirit is covered with snows of cynicism and the ice of pessimism, then you are grown old, even at twenty, but as long as your aerials are up, to catch the waves of optimism, there is hope you may die young at eighty.

A Japanese Vision

Samuel Ullman might have stayed a page in some local historical archive had it not been for that one poem that found its way to millions through publication in the mid-1940s. It was through that poem that a Japanese business executive working for JVC out of Tuscaloosa, Alabama, knew Ullman. Kenji Awakura explains there is a deep devotion that still exists today in Japan for the Alabamian:

> *I will explain it like this. After World War II the Japanese people were so deeply depressed in their thoughts. They felt they had lost their youth for nothing because of the war. Then the poem "Youth" taught them, "Don't be discouraged. Your youth is in each of you." It had not been lost because the time had gone. This poem told them, "Look, the value is in you. Be confident and stand up again on your feet!" These were strong messages of optimism and encouragement. "Youth" is believed to have helped Japanese industrial giants' hearts in resuming the country's economy after World War II. It is a historical fact that those people kept copies of this prose poem either in frames on the walls of their offices or in their wallets at their chests every day.*

Decades after the end of World War II, Awakura says that he still felt there were many people who lived with what he describes as "depressed hearts":

> *People got wealthier and physically stronger, but many of them are not very happy mentally. The world needs the "promotion song of life", "Youth" today and from now on. To enhance penetration of "Youth" will contribute to the world, I believe. And for that purpose, we better keep the original house of the poet where the poem was written.*

In 1992, Awakura began to work to see that the home of Samuel Ullman would be restored and set aside as a museum for future generations. Then first vice-president of the Japan-America Society of Alabama, Awakura led a fundraising effort in both Japan and the United States to restore the home and open it to the public. The property was given to the UAB Educational Foundation by JASA in 1993. Today it displays artifacts, furniture and materials from the Ullman family. The museum officially opened to the public in 1994.

The Samuel Ullman Home

This restored home is a beautiful place to get a feel for Samuel Ullman, who historians believe wrote the poetic essay "Youth" in the dining room here. Ullman lived here with his daughter Leah and her husband, a rabbi, Morris Newfield. This is a craftsman-style home, with heart of pine flooring and beautiful wood molding. Constructed in 1907, the home was one of the first to take advantage of electricity in the city. Apparently they didn't trust the idea of electricity completely, as the fixtures, which are original, contain cups to hold oil and wicks—just in case the power failed.

In the parlor or living room, family portraits hang on the walls. Visitors can see Samuel Ullman and Emma on their wedding day; their six surviving children; and Ullman with his grandchildren all around him. A map traces Ullman's travels throughout his lifetime. Other images throughout the home help lead visitors through Ullman's life and his many accomplishments and contributions to the Birmingham community. His poetic essay "Youth" has been translated into several different languages and hangs in the hallway. The inkwell Ullman used is here, along with other small personal items.

A highlight of the tour is a beautiful, hand-carved bed that Ullman had built for his wife as a wedding gift in 1867. It is made of rosewood and was crafted by Mr. C. Lee, a freed slave. The Ullman family continues to add artifacts to the museum, so there are often new things to see.

The Samuel Ullman Museum is operated by the University of Alabama at Birmingham. Tours can be arranged by calling 205-934-3328 or e-mailing isss@uab.edu. The museum is located at 2150 Fifteenth Avenue South, Birmingham, Alabama. A virtual tour of the museum, and details about the house and Samuel Ullman's life, can be found at http://main.uab.edu/Sites/UllmanMuseum/tour. A biography detailing Samuel Ullman's life has been written by Margaret Armbrester. It is titled Samuel Ullman and "Youth." *There is also a documentary on Ullman's life by Judith Schaefer of Marin County, California.*

BROTHER JAMES ALEXANDER BRYAN

When a young author set out to write the story of Brother Bryan's life, he asked the pastor how much he had helped the poor of Birmingham over one

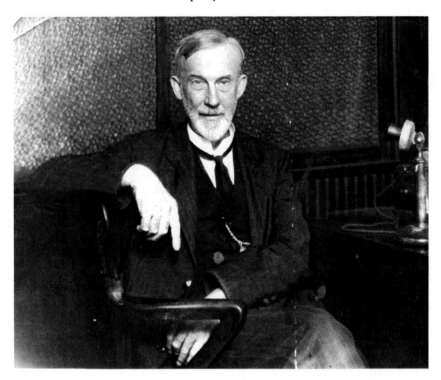

Above: Known simply as "Brother Bryan," this Presbyterian pastor said, "It is almost wicked to love a place like I love Birmingham." *Family of Brother Bryan.*

Below: Brother Bryan helped feed the homeless and went door to door helping the sick through some of Birmingham's most difficult times. *Family of Brother Bryan.*

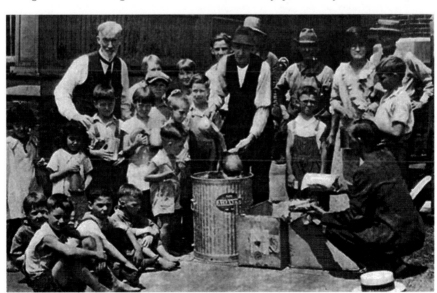

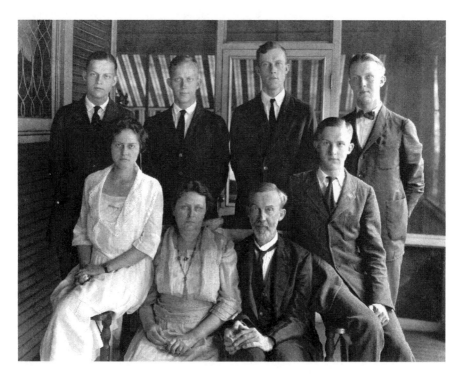

Above: Brother Bryan and his family on the front porch of their home on Sycamore Street. *Front row, left to right*: Mary Clayton, Mrs. Bryan, Brother Bryan and Harry Heywood. *Back row, left to right*: Augustin Clayton, James Howze, John Edwards and Thomas Claudius. *Family of Brother Bryan.*

Below: When Brother Bryan died, his body was carried to its final resting place atop a fire truck. Traffic is said to have stopped a block in all directions, and thousands attended the funeral. *Family of Brother Bryan.*

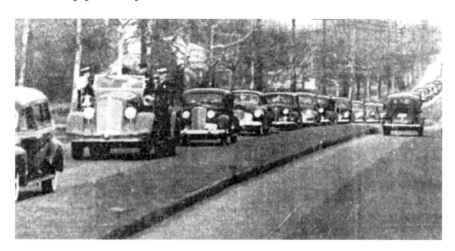

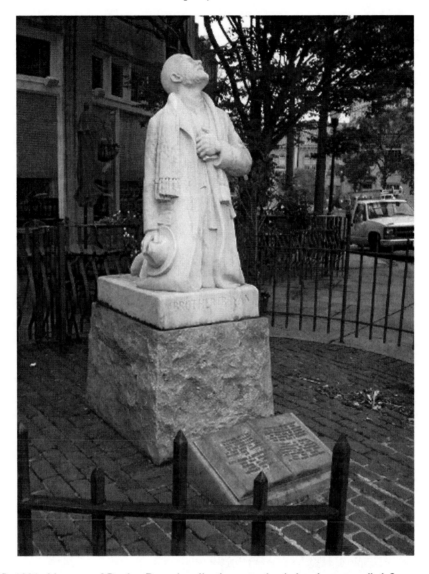

In 1934, this statue of Brother Bryan kneeling in prayer, hat in hand, was unveiled. It was created by sculptor George Bridges in honor of Bryan's many good deeds and work for the city. *Family of Brother Bryan.*

week. The answer said a lot about the man: "Son, I don't know. I am too busy to keep records. We leave that to the angels."

Brother Bryan may have left the record keeping to the angels, but he left everything else to God. Constantly in prayer, Brother Bryan would tell God about every need, and in case after case the need was met right on time. He

stopped constantly throughout the day and uttered the words everyone knew him best for: "Let us pray." With that, no matter what part of town he was in or how rough the group he was visiting, every hat would come off and every head would bow.

Brother Bryan's posture of prayer—kneeling, hat in hand—was so familiar to the citizens of Birmingham that when a statue of this beloved man was commissioned he was sculpted as everyone knew him, on his knees. This statue is one of the best-known landmarks in Birmingham, even though it has been moved several times. Today it sits in Five Points South, a crossroads area of the city, where this pastor can watch over a community, of which he once said: "I loved this city from the first and still love it. It is almost wicked to love a place like I love Birmingham."

Humble Beginnings

He wasn't always known as "Brother Bryan." Born in 1863, near Kingstree, South Carolina, James Alexander Bryan, came into this world while his father fought in the Civil War under Lee. After the war, he grew up in extreme poverty. His father returned to work the farm, and Bryan's educational opportunities were very limited. At the age of fourteen he had only completed the elementary level grades. Realizing the importance of education to their son, the parents sent young James to Raleigh, North Carolina, in 1877 to live with his aunt and attend Lovejoy Academy. He later received a scholarship to the University of North Carolina and studied there for four years.

When it came time to choose a profession, Bryan was torn between the law and the pulpit. He decided to become a preacher and worked to save enough to enroll in Princeton Theological Seminary. He received a scholarship, allowing him to finish his studies. It was as a student at Princeton University that he first found his way to Birmingham.

The Third Presbyterian Church in this little boomtown needed a part-time pastor for the summer. The church had been organized in 1884 but had never had a pastor. In July 1888, the congregation first heard young Bryan speak. When he returned to school in the fall, he continued his studies and near graduation had two job offers, one in Philadelphia and one in that little church in Birmingham.

Bryan wrote in 1889, "I have spent a long time in prayer, heart-searching, self-examination and earnest consideration, before the souls of these people in a town destined to be a southern Pittsburgh rolled over my heart and life." He had decided to move to Birmingham.

Not long after moving to the city and taking up his post, Bryan would meet someone who would become the very backbone of his ministry, Miss Leanora Clayton Howze. Bryan wasted no time in proposing to this young lady born of southern aristocracy. The story is that she flatly refused him at first. Then, as he had a habit of doing, Bryan suggested that they pray together before she made a final decision. After that prayer, she accepted his proposal. They wed in 1891. Over the years they had seven children, six living into adulthood.

The stories of Brother Bryan's ministry to the citizens of Birmingham are so many that it's hard to know where to begin. Hunter Blakely does as thorough a job as possible documenting Bryan's life in his biography *Religion in Shoes*. Published in 1934, the book has been reprinted several times. Written with the cooperation of Bryan and his friends and family, this is probably the most personal account to be found of the minister's life. It was dedicated to Bryan's wife, described as "the queen of a home and helpmeet of a very human saint." Most of the information in the book comes from a summer vacation spent with Bryan in 1931. In 1951, the book was updated, filling in the last ten years of Bryan's life.

A Minister for All

Bryan was unique in his time for his views on racial reconciliation. When studying at Princeton, he would go to the black churches in the area, where members would have him speak. He continued that tradition throughout his life, taking his message all over the city to people of all colors and all economic backgrounds. He worked in prisons, hospitals, factories, fire stations, police stations, on the radio, on the phone and through the newspaper. Brother Bryan was quite literally everywhere. His office, off the back of his house, was always open. Through the influenza epidemic in 1918 and the Depression, he was there. He ran two soup kitchens to feed and clothe the homeless. He married thousands of couples, officiated at many more funerals and reached tens of thousands with his preaching.

Often compared to St. Francis of Assisi, Bryan had a profound impact on people. Maybe it was because his motives were so simple and loving:

> *Sometimes tears come into your eyes when you watch men and women eating bread and drinking soup and milk. They are all dying for a little bit of love, for a kind word, for a warm handshake. Beneath that torn coat or ragged shawl, the life may be torn, but there is a soul for whom Jesus died, and if*

we can but point that soul to Christ by our unselfish life, by our loving life, then we will do our part in leading the world to Christ.

Bryan had a habit of coming home late at night without his overcoat because he'd given it to a man who needed it more than he. His wife had to hide money to be sure that there would be enough to feed their six children every week. If she didn't, Brother Bryan would give it away. He never worried where a meal would come from or what he would wear:

I never think of my own life without thinking of a verse in the sixth chapter of Matthew: "Consider the lilies of the field, how they grow; they toil not, neither do they spin: And yet I say unto you, that even Solomon in all his glory was not arrayed like one of these. Wherefore, if God so clothe the grass of the field, which today is, and tomorrow is cast into the oven, shall he not much more clothe you? Take no thought for these things, for your heavenly Father knoweth that ye have need of these things."

Bryan's faith that God would meet his needs did not, however, mean he was quiet or accepting. He believed that he was in a fight with the devil every day of his life. He absolutely hated alcohol, because of the damage he'd seen it do to families. He believed strongly in temperance. He also fought to keep Sunday a day on which stores and theatres were closed, taking a firm stand against a bill in the state legislature that would have allowed places of amusement to open on that day. He spoke to voters about supporting school bond issues and the importance of a good public education. He went to factories at the noon hours and preached. When those workers lost their jobs in the Depression, he helped them by the hundreds. He was an honorary member of unions all over the city.

Gifts for the Giver

One of the highlights of Bryan's life, and something about which he often spoke, was a trip to the Holy Land that his many supporters organized for him. Bryan used his experiences to bring to life the Bible for people all over the city. This was just one example of the generosity of the citizens to this pastor. When he needed a new horse and buggy, Birmingham's people raised money and bought him one. He was fitted with a new suit every year courtesy of the fire departments. It was a joke that every

Christmas, working closely with Mrs. Bryan, the fire department would set up a time to "kidnap" Brother Bryan. The proprietor of the men's clothing store would know that they were coming and was prepared to see to it that at least once a year the pastor got whatever he needed. When Third Presbyterian burnt down, funds were raised to rebuild Bryan's church. No matter what it was, if Brother Bryan needed it, someone would donate it or a fund would be established and the money raised with small contributions from all over the city.

In 1934, a visible memorial to this loved man's work for the city was built. Sculptor George Bridges had been commissioned by the Public Works Administration to create an art project for the city. He was given the freedom to choose his subject. There were many suggestions as to who should be so honored—a prominent banker, an industrialist or a civic leader? The artist had lived in Birmingham for a while, and as he asked himself what these people gave, and who gave the most, he kept coming back to the minister who had served all of Birmingham, regardless of color or religion or economic ability.

The project was kept quiet until it was well along. The sculptor attended services to study Bryan, and he decided that the most characteristic thing about his subject was the way he prayed. He bought an old overcoat and a long muffler, like Brother Bryan wore when he went around in the winter. He put those on an assistant and had him pose. The face and hands were from memory. A plaster model was made, and then the figure was carved into Alabama white marble. The dedication service for the statue was held on July 29, 1934, at Highlands Methodist Church near the intersection at Five Points.

On January 28, 1941, Brother Bryan died. His body was carried to its resting place on a fire truck. Thousands gathered at his funeral. Traffic stopped one block in all directions. The flag over city hall came to half-mast and stores closed. Some factories stopped work. Brother Bryan was almost seventy-eight years old. His final request was for a place to be established at which homeless men of Birmingham could always receive food, shelter and God's love. The Brother Bryan Mission was founded shortly before his death in 1940. It seems that Brother Bryan always got what he prayed for, and this was no exception.

Brother Bryan was named city chaplain on his sixty-seventh birthday, after forty-one years of service to Birmingham. The statue of Brother Bryan is made of white marble from Alabama and is located in a part of the city called Five Points, at Twentieth Street and

Eleventh Avenue. The statue has been moved a few times. It started out in Five Points, and then it was moved to Vulcan Park and then back to five Points. The Brother Bryan mission is located at 1616 Second Avenue North and has been serving the homeless since 1940. For information go to www.brotherbryanmission.com.

Chapter 2

COAL MINES, IRON ORE
AND *VULCAN*

Birmingham grew up on the backs of miners and ironworkers and still proudly identifies itself with that past to a large degree today. Proof of that pride in the past is the affection that exists for *Vulcan*, a symbol of the city's connection to the furnaces.

For many of those men who worked at places like Sloss Furnaces, the late 1800s and early 1900s were only a small step above slavery. Black labor dominated in industry, but strict segregation still existed. Workers used separate bathhouses and even attended separate company picnics based on race. Jobs were segregated, and blacks were restricted to lower-paying roles.

Low-cost housing was often built on the job site to attract sharecroppers looking to leave the fields and to ensure that a supply of labor was available around the clock. Significant change for workers began with the New Deal and the Fair Labor Standards Act of 1938, which raised the wages of southern laborers to that of their northern counterparts.

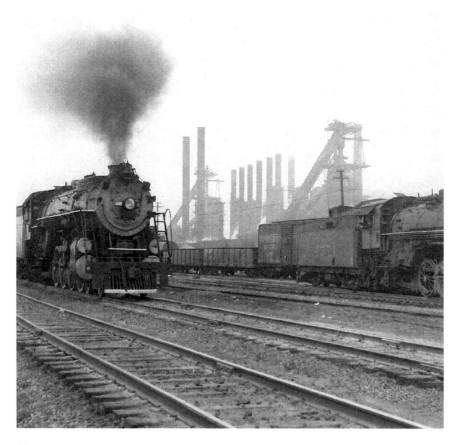

Birmingham's coal and iron ore industries were closely tied to the railroads. Here Sloss Furnaces is visible in the background of the train yard. *Sloss Furnaces.*

SLOSS FURNACES

For many in Birmingham, Sloss Furnaces is the most visible tie standing today to the city's industrial past. The fact that the facility still exists is thanks to residents who recognized its historical value and raised funds to save Sloss when it was on the verge of being demolished. The Sloss Furnace Association lobbied for preservation of the site, and in 1976 the group urged the city to commission a study showing the historical significance of Sloss. Birmingham's voters supported their efforts by approving a $3.3 million bond issue in 1977 to help preserve the landmark.

Coal Mines, Iron Ore and *Vulcan*

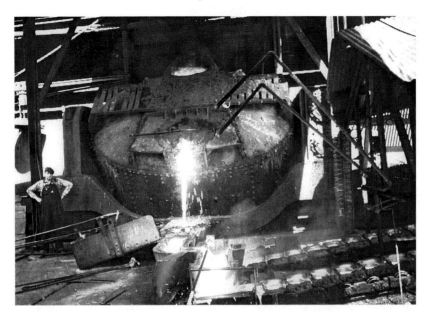

Above: At Sloss Furnaces, molten iron was poured into molds, which were cooled and then broken down into iron bars or "pigs." *Sloss Furnaces.*

Below: The furnaces at Sloss used to be tapped by hand, a process that helped release the molten iron. The heat was so intense that men working at the furnace notches had to be spelled every two or three minutes. *Sloss Furnaces.*

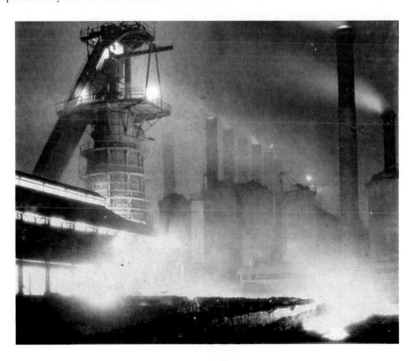

Why in so many people's minds was Sloss worth saving? It is likely because it represents much more than the city's industrial past. It is also a silent testament to the thousands who worked there and at other furnaces, feeding the beasts for decades.

A Perfect Place for Iron

The Birmingham area is unique in its geology, a fact that made it the perfect place for making iron. Jones Valley, at the heart of Birmingham, was the only place on earth at which large deposits of the three raw materials needed to make iron—coal, iron ore and limestone—were found in abundance close together. In the 1880s, furnaces were being erected in or near Birmingham almost as quickly as they could find men to build them. One of those furnaces would be the Sloss Furnace Company, founded in 1881 by Colonel James Withers Sloss. Colonel Sloss had many ties to the community. He was one of the founders of Birmingham and had a hand in establishing the Pratt Coal and Coke Company, along with Truman Aldrich and Henry DeBardeleben in 1878.

In 1881, Colonel Sloss formed his own company for the production of pig iron. His connections with Pratt Coal and Coke Company were advantageous, as DeBardeleben offered him coal at cost plus 10 percent for five years. The Louisville and Nashville Railroad gave him capital for the endeavor; with one of the railroad's officials, B.F. Guthrie, becoming vice-president of the new Sloss Furnace Company. With this backing, Colonel Sloss bought fifty acres of land from the Elyton Land Company, although some reports say the land was donated.

Work began immediately on the furnaces, under the supervision of engineer Harry Hargreaves, a Swiss-English immigrant who had studied under the English inventor Thomas Whitwell. The two furnaces built were of the Whitwell type—sixty feet tall and eighteen feet in diameter. The first of the furnaces was blown on April 12, 1882. The second was not blown until 1884 due to a shortage of coke. Colonel Sloss had to depend on other companies for most of his raw materials, even though he had purchased two limestone quarries and two iron ore mines. That first year, with one furnace running, twenty-four thousand tons of high-quality iron were produced.

Colonel Sloss did not stay as head of the new business for long. In 1886, he retired and the company sold to a group of investors. In 1887, the new partners renamed the firm the Sloss Iron and Steel Company. The addition of the word "steel" to the name was very intentional. The new owners

Coal Mines, Iron Ore and *Vulcan*

Birmingham residents recognized the historical value of Sloss Furnaces and saved it from the wrecking ball in the mid-1970s. *Sloss Furnaces.*

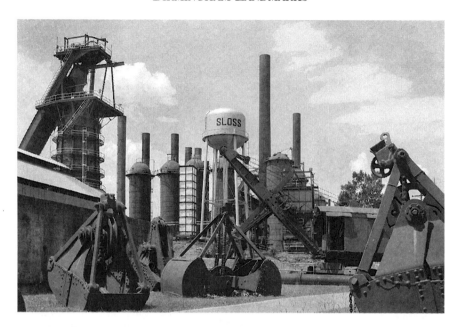

Sloss Furnaces is open to the public today, offering tours, special events and even classes in metal arts. *Marc Bondarenko. Sloss Furnaces.*

wanted to move the company away from the production of pig iron to that of steel. But there were challenges. Birmingham's local iron ore was high in phosphorus, which tended to produce inferior steel. Hopes were pinned on a new steel-making process that could eliminate the phosphorus. The patents for the process were owned by industrialist Andrew Carnegie of Pennsylvania, however, and an arrangement could never be reached for the Sloss Iron and Steel Company to use the technology.

The company built two more furnaces, bought coal lands, acquired the Coalburg Coal and Coke Company and constructed three hundred new coke ovens. It was a move toward vertical integration that would set the company up for financial strain as the nation entered an economic depression in the 1890s that caused mining and furnace companies in the state to begin to fail. Sloss Iron and Steel held on until a boom in 1898 helped get it back on its feet, and a new expansion program began. The Sloss Iron and Steel Company bought three more furnaces, twenty thousand acres of brown ore land, twenty thousand acres of coal land and twelve smaller companies. Sloss was now second in size to just one other company in the South, Tennessee Coal, Iron and Railroad Company.

In 1899, the Sloss Iron and Steel Company reorganized again, this time becoming the Sloss-Sheffield Steel and Iron Company. Much of the focus

returned to producing high-quality pig iron for foundries moving to the state. Things stayed on a fairly steady course for about fifteen years, with J.C. Mabel as chief executive officer. Sloss was one of the two biggest producers of pig iron in the South.

The Pittsburgh Steel Tax

The purchase of the Tennessee Coal, Iron and Railroad Company (TCI) in 1907 by J.P. Morgan had a direct impact on the financial future of Sloss-Sheffield and other southern iron companies. Morgan was a New York investment banker and creator of the world's largest company at the time, United States Steel Corporation. Initially, southerners thought that it was a good thing to be under the wings of such a huge corporation. As it turned out, they ended up being under its thumb.

Officials at U.S. Steel did not want TCI competing with their operations in Pittsburgh. A discriminatory pricing formula, called "Pittsburgh Plus," was put in place on iron and steel coming out of the South. Pittsburgh Plus put a fee on rail shipments out of Alabama, cutting out any price advantage the southern manufacturers may have had. Sloss-Sheffield's profitability was affected by the new pricing structure, as well as its slowness to adapt to new technology. By the 1920s, it became clear that Sloss-Sheffield would have to modernize or close. A major overhaul took place, which kept the doors open for nearly fifty more years, even through the Great Depression.

The Human Toll

One of the reasons southern manufacturers like Sloss-Sheffield were slow to modernize equipment, and could price product below their counterparts in the North, was a reliance on manual labor. Most laborers were black, many displaced from work in farming after the Civil War. Some estimates are that blacks outnumbered whites five to one in the iron and steel plants. But there were also many immigrants, who came to this country for a better life and started that life working in mines or iron and steel plants. In Birmingham, many of those immigrants were from Italy, Greece and Ireland.

Before Colonel Sloss sold the furnace, it is recorded that he employed 565 black men, housing some in forty-eight tenements on the property. These men produced about one hundred tons of iron per day, all cast in sand.

Only after southern blacks began to migrate to the North in the 1920s did Sloss-Sheffield modernize. They installed an automatic pig-casting machine and upgraded furnaces. After mechanization, each furnace produced over four hundred tons of iron per day. Prior to this upgrading, the process was dangerous, backbreaking work. Here's a description of the process from the Sloss Furnaces application to the National Register of Historic Places:

Significantly, most of the loaders and carriers at the Sloss Furnaces were black. Loaders worked on platforms at the top of the furnaces and emptied elevator carloads of raw materials into the furnace, according to a formula. This work was arduous and quite dangerous due to almost constant leakage of gas from the furnaces. The furnaces were also tapped by hand, and the heat was so intense that men working at the furnace notches had to be spelled every two or three minutes during the 10 to 15 minute notching or tapping process. Iron carriers performed probably the most laborious work. They formed channels in the sand floors of the huge casting sheds, and after the molten iron had been permitted to run through these channels into hundreds of sand molds and had cooled, the men used crowbars and sledge hammers to break off the iron bars or "pigs" which they then carried across the loose sand to waiting rail cars. Each bar weighted 100 to 115 pounds.

The Great Depression hit Birmingham's economy hard. Sloss suffered as production of steel and pig iron dropped to their lowest levels since 1896. Labor reforms under the New Deal were the focus of many bitter battles, especially the Fair Labor Standards Act of 1938, which raised the wages of southern laborers to that of their northern counterparts. Labor unions began to grow, and unemployment hit levels that had never been seen before. Then along came World War II, and the country began to go to work again. Sloss-Sheffield managed to hang on through the war, even though earnings were held down by federal taxes on anything considered an excess profit, aimed at discouraging profiteering from the war.

In 1942, the last big evolution for Sloss-Sheffield began. The company was purchased by the United States Pipe and Foundry Company (USP&F). The purchase meant that Sloss-Sheffield would have a steady market for its pig iron filling the parent firm's needs. Profit taxes were lifted soon thereafter and earnings began to soar. Another positive move came when the courts found the Pittsburgh Plus pricing structure illegal.

The USP&F merged with Sloss-Sheffield in 1952, and moved its headquarters to Birmingham. In 1956, the company began construction of

an ultramodern blast furnace to compete with overseas firms. By the time the new facility was ready, though, German and Japanese blast furnaces were exporting iron to the United States at prices lower than domestic manufacturers could sell it for. This began a period of serious financial problems for the iron and steel industry in Alabama.

Eventually Jim Walter Corporation, a maker of prefabricated homes, bought USP&F. The new owners realized that the state's coal demanded a higher price in foreign markets than did coke-fired pig iron. Thus began the move to close down the last active furnace in Birmingham. In 1970, USP&F's last active furnace in Birmingham shut down. Before it could be demolished, however, Sloss Furnaces became one of the first industrial sites in the United States to be preserved for public use. In 1981, it was designated a National Historic Landmark by the U.S. Department of the Interior.

Visiting Sloss Today

Few places give visitors such an authentic and unusual way to step back in time as does Sloss Furnaces. Visitors can walk the grounds, attend concerts, see Shakespeare performed, attend festivals on the site or enroll in the nationally recognized metal arts program. There is an interpretive museum of industry on site as well. Curiosities for many are the ghost stories surrounding the site. The most commonly told story, and one that is fairly well documented, involves an assistant foundryman who died in a tragic accident.

Theophilus Calvin Jowers was the fateful foundryman. He had worked for years in the iron business and frequently told his wife that he would always work at a furnace. He was proud to be an iron man. His wife was afraid of the dangerous work he did, perhaps having some premonition of his death. In 1887, he was working at the Alice Furnace #1 in Birmingham. He was up on the furnace trying to install a new bell. Using a block and tackle to help, he walked around the edge of the furnace and lost his balance. Jowers fell into the molten iron below. His fellow workers tried to retrieve him, but he was instantly burned up. Some versions of the story, including a report in the *Birmingham News* dated September 10, 1887, claim that they recovered some body parts including Jowers's head. Not long after his death, people reported seeing his ghost walking around checking things. For more than twenty years, Jowers was seen at the Alice furnace. After it was demolished, his ghost began to be reported at Sloss.

Other ghost stories include the standard reports of things being moved from where they were left, doors opening and closing by themselves and shadowy figures. It's a part of history visitors to the site will have to judge for themselves.

Sloss Furnaces is located at First Avenue and Thirty-second Street. The plant was founded by Colonel James Withers Sloss. Sloss Furnaces is open to the public today and also serves as a venue for several community activities like concerts, plays, barbecues and metal arts classes. To find out hours for a visit, order tickets or get information on the metalworking program go to www.slossfurnaces.com or call 205-324-1911. Sloss Furnaces was named a National Historic Landmark in 1981 and is the only twentieth-century blast furnace plant in the world currently being preserved and interpreted as a museum. In February 2009, Sloss added a SLSF 4018 steam locomotive to its site as part of the process to become part of a linear park that will run east–west through downtown Birmingham.

RUFFNER MOUNTAIN NATURE CENTER

Once a hub of mining activity, Ruffner Mountain today is a 1,011-acre nature center in downtown Birmingham. Ruffner sits on one of the last undeveloped stretches of the Red Mountain ridge, a testament to both the industrial past of this city and to its current day sensitivity to conservation and ecology.

Birmingham's location and founding were all about the geology. This is reported to be the only place in the world where the three raw materials needed to create iron are found so close together. Those elements are coal, iron ore and limestone. But what once made Birmingham such a prosperous and fast-growing city was also a key to its decline. The city's industrial backbone was made of iron, but it wouldn't be strong enough to withstand the future alone.

The Great Depression that began in 1929 saw production of steel and pig iron in the Magic City drop to the lowest levels since 1896. A reemergence during World War II helped bump employment back up, and by the 1950s there was high demand for foundry pig iron. But German and Japanese blast furnaces, built with U.S. foreign aid in the late 1950s, marked the beginning of the end. These countries were exporting iron to the United States at prices lower than those of domestic producers. By 1970, the last active furnace in Birmingham had shut its doors.

Coal Mines, Iron Ore and *Vulcan*

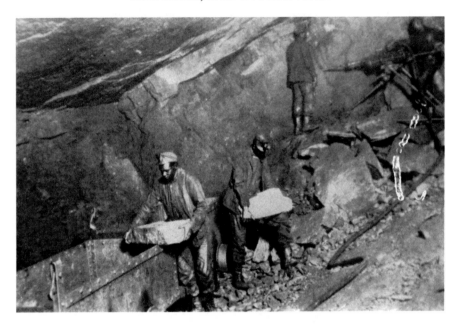

Above: Ruffner Mountain Nature Center was once a hub of mining activity. Here workers load ore, possibly for use at nearby Sloss Furnaces. *Ruffner Mountain Nature Center.*

Below: This drift workings mine was a part of Ruffner. Drift workings is a method of subsurface or underground mining. *Ruffner Mountain Nature Center.*

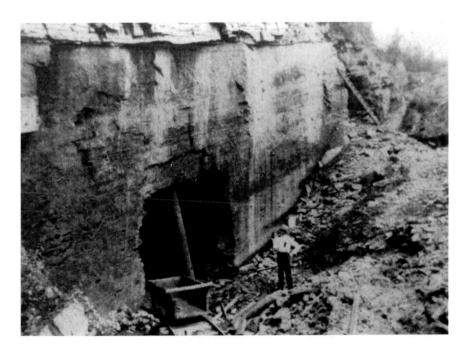

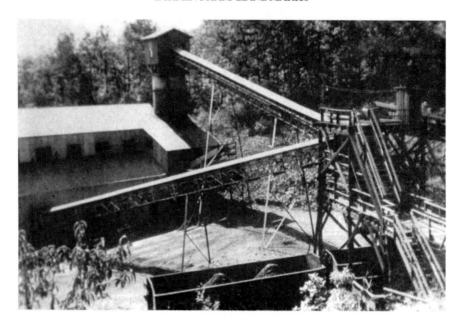

An ore processing facility was a part of Ruffner when the area was being mined. *Ruffner Mountain Nature Center.*

Today Ruffner Mountain Nature Center sits squarely at the center of this period of the city's industrial history. It began with the purchase of twenty-eight acres of largely forgotten mining land in 1977 and has grown dramatically since then. Working with groups like Forever Wild and the Trust for Public Land, and garnering donations from United Land and others, the preserve has grown to more than one thousand acres. The master plan calls for adding five hundred to six hundred more acres and the completion of a new visitor center.

What makes Ruffner truly unique are the diverse environments that make up the preserve. In 2008, for example, a wetlands area was added. This includes small pools, native grasses and wetland plants. The area is fed from an artesian well near the Irondale side of the park. There is an unnamed trail leading to the area and a boardwalk around it.

Marilyn Raney, interim director at Ruffner, says there are several species of state-listed plants on the property. In terms of unique animal life, probably the most unusual is found at the Red Lakes. These lakes are pools left over from the mining era. Bright red in color from the iron ore, for years it was thought that nothing could live in them. In recent years, though, scientists have found the Red Lakes to be teeming with microscopic creatures, especially fairy shrimp. Studies continue on this phenomenon, with researchers from several universities making the trek to the pools.

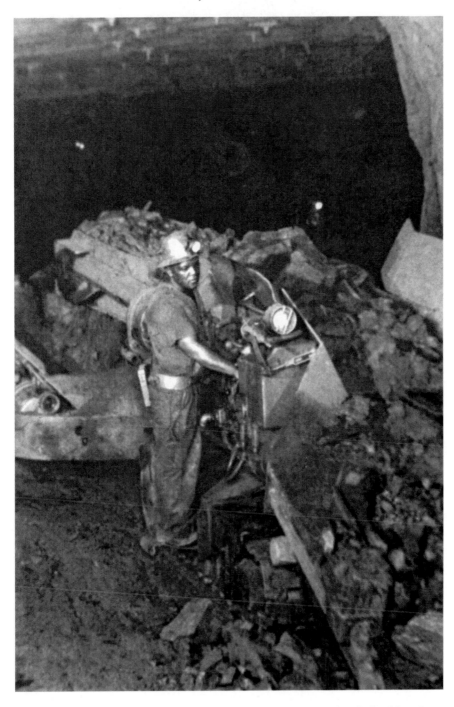

Mining was arduous work, often paying just two or three dollars per day. *Ruffner Mountain Nature Center.*

Today Ruffner Mountain offers views of several of the old mine structures and related facilities, including this crusher. *Bob Farley/f8 Photo, Ruffner Mountain Nature Center.*

Coal Mines, Iron Ore and *Vulcan*

Special tours, led by Ruffner Mountain experts, allow hikers to see sites like this abandoned mine. *Bob Farley/f8 Photo, Ruffner Nature Center.*

All total there are more than twelve miles of hiking trails through Ruffner, along with Alabama animal exhibits, outings and guided tours. In 2009, a new Tree Top Visitor Center and Mountainside Pavilion Complex opened, featuring environmentally green building designs. The six-thousand-square-foot building and educational pavilion was designed to meet the U.S. Green Building Council's LEED certification.

Trails Overview

The trails at Ruffner range in difficulty from easy and short to strenuous and long. The trails interconnect to the visitor center. Hikes include the Buckeye Trail (1.6 miles), the Geology Trail (0.5 miles), the Marian Harnach Nature Trail (0.6 miles), the Mines Hike (3 miles), the Quarry Trail (4.2 miles), the Ridge and Valley Combo (2.5 miles) and the Trillium/Hollow Tree Trail (1.2 miles). Some of the hikes are guided only. Here's a look at some of the details:

BUCKEYE TRAIL: This trail is rated "easy/moderate," with a hiking time of one and a half hours. The trail is named for the buckeye trees that line parts of the path. This is a good trail for spring, when the buckeyes are in bloom. At one point on the trail there is a live, ninety-foot chestnut oak that began growing about 1800.

GEOLOGY TRAIL: A short, easy walk, this trail takes about thirty minutes to traverse. The focus of this area is on the iron ore and limestone that were mined over much of Ruffner Mountain from the 1850s to the 1950s. Turtle Rock, a limestone boulder about the size of a car, is said to be some 450 million years old.

MARIAN HARNACH NATURE TRAIL: Named for a longtime supporter and volunteer at Ruffner, this trail is another short, easy trek that should take about thirty minutes to travel. This is oak/hickory forest, affording opportunities for birdwatching. A 150-year-old white oak is a highlight of this short trail.

MINES HIKE: If you have the time and want to immerse yourself in Birmingham's industrial past, the mines hike is a great choice. This is a guided hike, rated "moderate/difficult." Allow five hours for this hike, which will give you access to a number of mining artifacts. The tour features drift mine openings, a sheave pillar that was used to raise and lower ore cars and foundations for crushers, motors and hoists. One of the more complete mine sites on the tour was owned by Sloss Iron and Steel Company. Artifacts at this site include a crusher, remnants of the hoist house and an opening to the slope mine, which was built after all surface ore was removed from the area.

QUARRY TRAIL: At 4.2 miles, the quarry trail will take about one and a half hours to cover. This is probably the most popular long trail at Ruffner. The hike is moderate and yields some great overlooks along the way. This trail takes visitors to an abandoned limestone quarry. Along the way there are plenty of hardwood forest, iron-ore pits and several limestone and sandstone formations. This trail is a favorite among visitors, with a balloon off the end that turns into the Overlook Trail, with spurs to Hawks' View Overlook and Sloss Peak.

RIDGE AND VALLEY TRAIL: Many consider this the most difficult trail at Ruffner. It moves through hardwood forest, mining excavation sites, streams and valleys. The Ridge and Valley Trail splits off of the Quarry Trail. There are several steep descents here, making it a good trail for a more experienced hiker. Allow at least one and a half hours to travel the 2.5-mile trail.

TRILLIUM/HOLLOW TREE TRAIL: An easy hike, this trail is more pastoral than the rest. It's a pleasant walk in the spring when wildflowers are in bloom. The trail is named for a 150-year-old tulip tree. After fire damage, the hollowed-out tree was taken down.

Ruffner Mountain Nature Center started with just twenty-eight acres purchased in 1977. Today it is over one thousand acres in size, with more expansions planned. Ruffner is a certified wildlife habitat by the Wildlife Habitat Council. Ruffner Mountain Nature Center

is located at 1214 Eighty-first Street South, Birmingham, Alabama. For information, including trail maps, go to www.ruffnermountain.org. Ruffner Mountain Nature Center is open Monday through Saturday, 9:00 a.m. to 5:00 p.m. and Sunday from 1:00 p.m. to 5:00 p.m. On Mondays, the visitors' center is closed, but trails are open. There is no admission, but donations are appreciated. To inquire about a guided hike or one of Ruffner's educational programs, call 205-833-8264.

VULCAN

From the time he was commissioned in 1903, all the way up to present day, *Vulcan* has probably been the best salesman the city of Birmingham has ever had. There have been some ups and downs, and some say that he lost his dignity a few times over the years, but today this fifty-ton cast-iron statue sits prominently atop Red Mountain, a visible sign of Birmingham and its history.

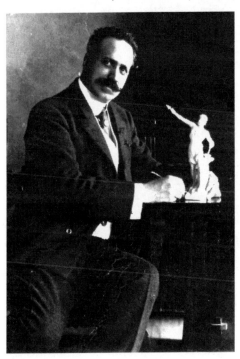

Italian sculptor Giuseppe Moretti was chosen to create *Vulcan* in 1903. Here he is pictured with a model of the statue. *Vulcan Park and Museum.*

Birmingham was still a relatively young city when the idea to create *Vulcan* came about. Since its founding in 1871, Birmingham had grown so quickly people had begun referring to it as the "Magic City." The city's Commercial Club, a precursor to the chamber of commerce, wanted to promote Birmingham at the upcoming 1904 World's Fair in St. Louis by entering an exhibit. It had to be something that reflected the industrial nature of this southern city and something that would draw attention. By 1903, the Commercial Club had deemed Vulcan the perfect representative.

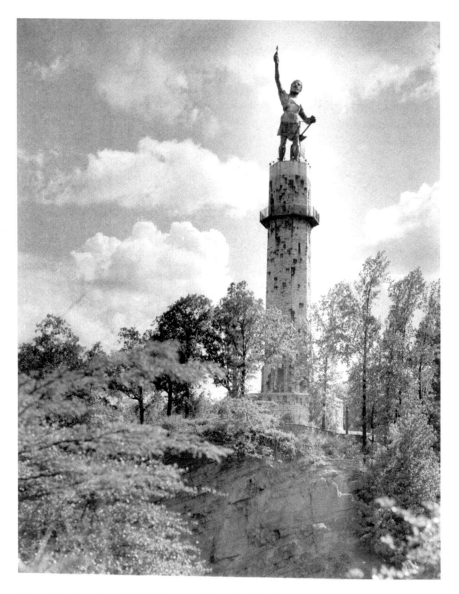

The rock pedestal on which *Vulcan* stands is made of sandstone from the area and is 124 feet tall. Steps inside the pedestal take visitors to the top. *Vulcan Park and Museum.*

Why Vulcan? The reasoning was pretty straightforward. Vulcan was the Roman god of the forge. A forge is a place with a furnace, where metal is heated until someone like a blacksmith can hammer it into useful things. And a blacksmith was essentially what Vulcan was.

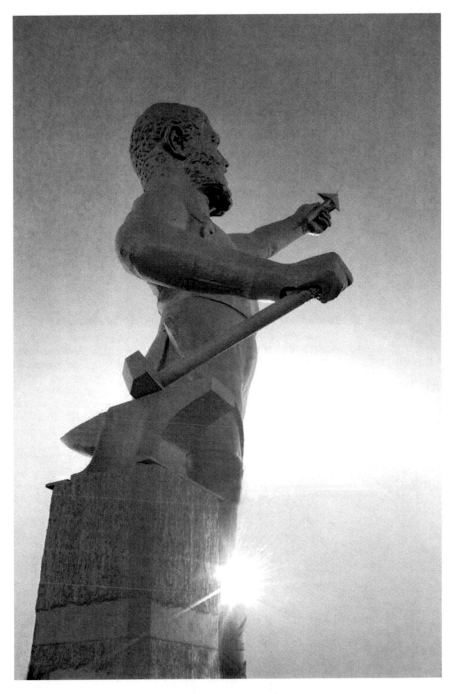

Vulcan Park was listed in the National Register for Historic Places in 1976 and is recipient of a National Trust for Historic Preservation Honor Award. *Rob Lagerstrom, Vulcan Park and Museum.*

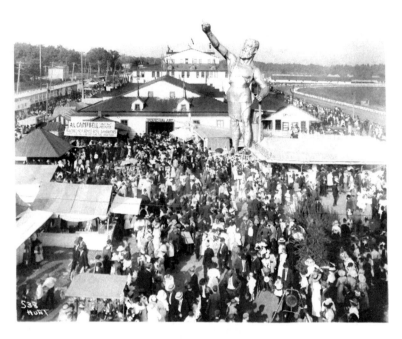

Above: After *Vulcan* returned from the World's Fair, he was reassembled at the Alabama State Fairgrounds, where he was used to promote a variety of products. *Vulcan Park and Museum.*

Below: *Vulcan* underwent an extensive restoration beginning in 1999. In some cases, pieces of *Vulcan* were recast using sculptor Giuseppe Moretti's original drawings. *Vulcan Park and Museum.*

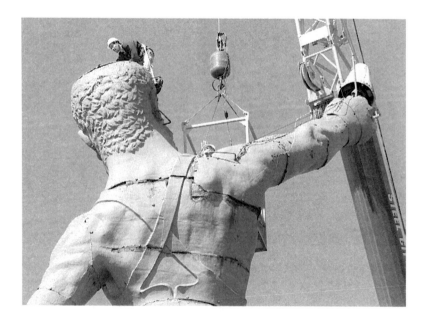

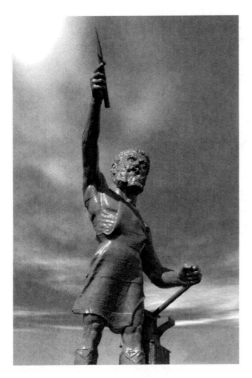

Today *Vulcan* has been restored and stands atop Red Mountain in the city of Birmingham. He weighs fifty tons and stands fifty-six feet tall. *Rob Lagerstrom, Vulcan Park and Museum.*

Vulcan was identified with the Greek smith-god Hephaestus. His father was Jupiter and his mother was Juno. Jupiter was the supreme ruler of the universe, and Juno was perfect in every way. What a disappointment their son Hephaestus must have been. He was ugly and disfigured. So the beautiful beings threw him from Mount Olympus. He fell from the sky for an entire day until he landed on the island of Lemnos in the Aegean Sea. Here he began to work as a blacksmith, using the volcano on the island as his forge. One-eyed cyclopes were his helpers. He made weapons and armor for the gods and ended up marrying Venus, a goddess of beauty and love. So in the end he did pretty well for himself.

Because Vulcan was god of the forge, he seemed a standout subject for a statue to represent Birmingham at the World's Fair. James MacKnight, manager of the Alabama State Fair and secretary of the Commercial Club, is credited with choosing Vulcan. The statue would symbolize the city's origins in the iron and steel industry. MacKnight is also credited with choosing *Vulcan*'s creator, Italian sculptor Giuseppe Moretti.

Choosing a Sculptor

Moretti was already an acclaimed sculptor when MacKnight suggested him for the commission. He had trained in studios in Italy, Croatia and Hungary. He cast sculptures in bronze using the lost-wax method and had already done several pieces in the United States. But his favorite medium was white marble.

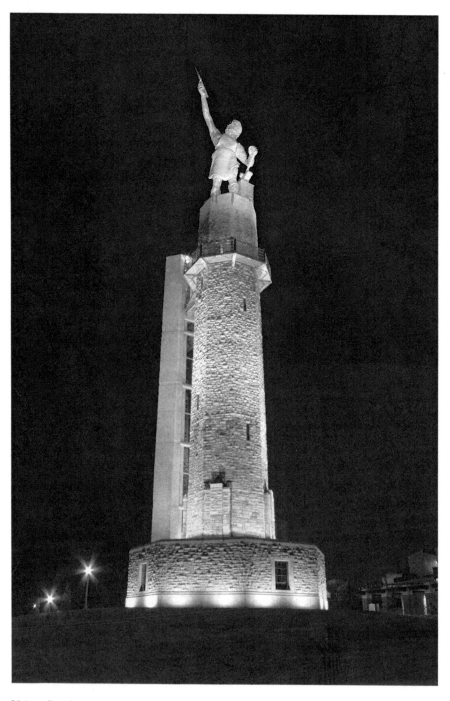

Vulcan Park is the site of the largest fireworks show in the Southeast today, known as Thunder on the Mountain. It's held on the Fourth of July. *Vulcan Park and Museum.*

Coal Mines, Iron Ore and *Vulcan*

After moving to America in 1888, Moretti set up a studio in New York, where he soon found a clientele. He worked with well-known architect Richard Morris Hunt on several commissions in Rhode Island. He began doing large pieces for a park in Pittsburgh, Pennsylvania, in the 1890s. It's possible that this is how MacKnight came to know about him. Birmingham was, after all, "the Pittsburgh of the South." In 1903, Moretti came to Alabama to discuss the commission. It was far from decided that he would be the sculptor. Moretti was one of several artists being considered for the job. He won the commission for two reasons: a good price and a willingness to meet the completion schedule MacKnight had set. The huge plaster model from which the statue would be cast would cost about $12,000, according to other contenders for the commission. Moretti, however, for reasons unknown, said that he could do it for half of that—$6,000. And he agreed to complete it about forty days after a contract was reached.

The initial model was built in New Jersey in an unfinished church building during the winter of 1903 to 1904. Clay was applied over a wooden frame, and because of the size it was done in two pieces—the top and the bottom half of *Vulcan*. The full-size clay model was then used for the plaster molds. These molds were carefully packed and shipped back to Birmingham. Moretti followed his work to Alabama to supervise its evolution into iron.

An Ugly *Vulcan*

The city's socially elite were abuzz with talk about this commission and the work of art that would be representing Birmingham at the World's Fair. Concerns were raised that *Vulcan* would be misshapen and ugly. Moretti began to get defensive, probably worried that there would be some kind of public outcry over *Vulcan* when it was unveiled He is said to have told friends, "Do they not know, these people who say my Vulcan is unshapely, that his mother Juno cast him from heaven because his body was distorted?"

MacKnight did a little creative public relations work to lay the groundwork for Moretti and his *Vulcan*. He wrote an article for the *Birmingham News* heralding the arrival of *Vulcan* and Moretti. Here's an excerpt of what he wrote:

> *It is only fair to Mr. Moretti to say that he is doing Birmingham a great service in taking the commission to build this great statue of Vulcan. He is*

actually doing it at considerable sacrifice to himself, and with a certainty of being obliged to postpone some of his other important commissions; but he told me frankly that he realized how important this work would be to the artist who undertook it, if it were properly done, and that the fame to be derived from it was a more important consideration to him than the price to be paid. If the artist of this work can take such a view of the matter what must be its advertising value to Birmingham?...In conclusion it may be stated without betraying any confidence that Mr. Moretti is the instructor of several ambitious young members of the millionaire set in New York, who have well-equipped studios, and are seriously interested in modeling the "human form divine."

To be absolutely sure he had cleared the way for Moretti, MacKnight added that the artist was a bachelor, and "what will he do to the hearts of some of the belles of the South when he comes down here in February remains to be seen." This seemed to have changed the complexion of the situation completely.

With the plaster mold in the city, the next step was to turn it to iron. J.R. McWane's Birmingham Steel and Iron Company used the plaster molds and cast the statue one piece at a time out of Sloss No. 2 pig iron, made from iron found on Red Mountain. There are twenty-one total pieces to *Vulcan*. Once cast, the pieces went to St. Louis, where Moretti would assemble them on site at the World's Fair. The statue was completed and dedicated on June 7, 1904, in the Palace of Mines and Metallurgy; it was christened with water from Birmingham's own Cahaba River. Vulcan stood with anvil at his left side, a hammer in his left hand and a spear in his right—held up so he could admire his work. The statue won the grand prize at the fair, along with medals for Moretti and the foundry that created *Vulcan*.

Back to the Fairgrounds

In 1905, after the Worlds Fair ended, *Vulcan* was disassembled in order to be moved. The pieces were taken by train to *Vulcan's* new home in Birmingham. His parts lay about on top of Red Mountain, alongside the railroad tracks of the Birmingham Mineral Railroad for eighteen months, waiting for city leaders to decide exactly where he should be put back together. Some wanted him in the downtown area, in what is today Linn

Park. Others believed he should stand atop Red Mountain. Neither side won out.

He was eventually reassembled at the Alabama State Fairgrounds. Thus began a rather undignified phase of *Vulcan*'s life. He stayed at the fairgrounds for nearly thirty years, during which time he silently hawked goods like pickles, ice cream cones and Coke. These products fit in his right hand, which was put on backward when he was reassembled. The spear Moretti had sculpted for him was lost on the way back to Alabama. His left hand was also askew, which threw *Vulcan*'s balance off to the point that he had to be propped up with a timber. Eventually someone came up with the idea of putting him in a giant pair of Liberty overalls. He began to be painted, first in the 1930s in flesh tones. One can only imagine what Venus would have thought of it all.

Oddly enough, it was the Great Depression that helped make it possible to get *Vulcan* back to Red Mountain and put in a premier position. Some city leaders were astute enough to realize that a treasure was being squandered as *Vulcan* stood wasting away at the fairgrounds. The Kiwanis Club spearheaded an effort in 1935 to move him to the more prominent spot. The process was helped along when the government formed the Works Progress Administration, meant to put people back to work during the Great Depression. The WPA agreed to help get the land ready for *Vulcan* and to build a sandstone pedestal, some 124 feet high. In 1939, *Vulcan* was dedicated in its new spot, with a nine-day-long celebration.

In 1946, someone in the Birmingham Jaycees safety committee came up with the bright idea of placing a lighted beacon in Vulcan's upheld hand. It would be visible all over the city and into the suburbs. The beacon would shine green on days when no one died on the area's highways and red when a fatality occurred. It was thought that this would encourage people to drive more carefully. The beacon, or torch, was removed during a later renovation but is still visible inside the Vulcan Center Museum. Visitors can push a button to light the torch.

In the 1970s, steps were taken to renovate and improve the park and *Vulcan* itself. A marble-covered enclosure and observation deck were added, covering the original sandstone pedestal. In hindsight it wasn't much of an improvement. The marble covered up the stonework, which was an important part of the park, and made it nearly impossible to see the figure when standing directly below him. There was also another paint job, this time turning Vulcan the color of iron ore.

Saving Vulcan

By 1999, all of the wear and tear of being moved and standing out in the elements began to take their toll. *Vulcan* was in need of a serious overhaul. The concrete that had been poured into the hollow statue to anchor him in place all these years had expanded and contracted over time with temperature shifts, creating cracks in the statue. The process was made worse by the fact that *Vulcan's* head has no top, so rain poured into the opening. *Vulcan* came down, this time to be completely reworked.

Disassembled, all of *Vulcan's* individual parts were sent to Robinson Iron and Steel of Alexander City. Here he was repaired, and if needed pieces were completely recast. The workers used Moretti's original drawings. He was painted grey, his original color, and returned to Vulcan Park, where he was reassembled in 2003. In June 2004, *Vulcan* was rededicated and christened with water from the Cahaba River in honor of his 100th birthday. Here *Vulcan* has one of the most scenic spots in the city from which to look out, and he can be seen on the horizon from almost every direction. The park is the site of the largest fireworks show in the state today, known as Thunder on the Mountain, held on the Fourth of July every year.

Moretti's Marble Obsession

Vulcan, and Moretti's work in Alabama, tied the artist to this state in a way that was quite extraordinary. Soon after he arrived in Birmingham in 1903, Moretti began to hear about the area's unique mineral deposits. He went to visit John Adams, an expert on the subject, and saw on Adams's desk a marble Bible. When asked what material the Bible was made from, Adams told him that it was white marble from a quarry in Sylacauga, about thirty miles outside of Birmingham. Moretti wanted to see the quarry and spent weeks exploring the state's marble areas. He found a near perfect piece of stone that he took back to his studio and used as a medium for a life-sized piece he called *Head of Christ*. This was the first known work of fine art made from Alabama marble. It was finished in 1904 and shared exhibition space at the St. Louis World's Fair with *Vulcan*.

Moretti hoped that *Head of Christ* would show other artists around the world the fine quality of natural materials found in Alabama. The piece won a silver medal at the World's Fair and became Moretti's most

cherished work. He carried it with him wherever he went in the world and refused to sell it. He once told a friend, when speaking of *Head of Christ*, "I have a peculiar affection for it. Where I go, my Christ goes also…I feel the final resting place of this first sculpture from Alabama marble should be in that state."

Head of Christ stayed in the Moretti family after the artist's death in 1935. His widow, Dorothea, had been contacted about returning the piece to Birmingham for the rededication of *Vulcan* when the statue returned to Red Mountain in 1939. *Head of Christ* was to be prominently displayed at Vulcan Park. But there began to be talk that the sculpture should stay there permanently, and the newspapers reported this. Someone mailed the widow Moretti clippings that made it clear that Birmingham wanted to keep the piece, and she, perhaps afraid that the piece would not be returned, refused to send it. She later sent word to the city that she

Giuseppe Moretti's *Head of Christ* sculpture was created from Alabama white marble. It was displayed along with *Vulcan* at the St. Louis World's Fair in 1904 and today is on display in the Alabama Department of Archives and History in Montgomery.

intended to give *Head of Christ* to the State of Alabama, where it would be placed in the State Memorial Building, now the Alabama Department of Archives and History. The piece was shipped to the archives on October 28, 1940. It was put on exhibit January 1941 and has been almost continually displayed since then.

Vulcan Park and Museum is located at 1701 Valley View Drive, Birmingham, Alabama. Park grounds are open every day from 7:00 a.m. to 10:00 p.m. The Vulcan Center Museum is open Monday through Saturday 10:00 a.m. to 6:00 p.m. and on Sunday from 1:00 p.m. to 6:00 p.m. There is an observation balcony and a gift shop. There is a charge for admission; rates vary with age and time. Go to www.visitvulcan.com for current information. Vulcan's pedestal is 124 feet; there are stairs inside to reach the top. Vulcan Park was listed in the National Register for Historic Places in 1976 and has won a long list of awards, including the National Trust for Historic Preservation Honor Award. Vulcan weighs fifty tons and stands 56 feet tall. Through public and private partnerships, $15.5 million was raised to preserve Vulcan and to reinstate the park that is his home today. Vulcan Park is a popular destination for visitors to the city. People from all fifty states have visited the site, as well as people from more than seventy-five countries.

Chapter 3

PLACES OF GROWTH
AND RECONCILIATION

Birmingham has always been a city of two faces. Which face a person here lived with, and grew up seeing, had everything to do with the color of his skin.

This could be a city of gentility and kindness. Yet it carried the embarrassment of being nicknamed "Bombingham." For here grown men who hid in the shadows would kill or maim to keep whites and blacks from sitting together at a lunch counter or sharing a schoolroom. It was in this city, in which pastors spoke of God's love and fed the hungry, that four young girls died while putting on their choir robes one Sunday morning. In this city some marched for their civil rights, while others aimed fire hoses at them or let dogs loose to attack them. It is a city of pride and a city of shame.

Today Birmingham has come a long way toward acknowledging both sides of its past. The downtown area now includes a civil rights district, highlighting the struggles of the 1950s and 1960s. The Civil Rights Institute is the anchor of this district, sitting squarely in the center of three of the biggest civil rights landmarks anywhere: Kelly Ingram Park, Sixteenth Street Baptist Church and Gaston Motel.

Kelly Ingram Park, where protestors marched for their civil rights, is today marked by a sign reminding visitors that Birmingham is a "Place of Revolution and Reconciliation." *Claire Vath.*

ALABAMA PENNY SAVINGS BANK

The Alabama Penny Savings Bank was in many ways a foundation on which the early, free black community would build its future. For many people, the lead architect of that building project was Reverend William R. Pettiford.

Pettiford was a pastor first, last and always. But he was unique in that he saw opportunities to use his faith in a way that would serve the community and advance people's lives through their pocketbooks. He set aside his formal role as pastor when he took over the post as president of the Alabama Penny Savings Bank. The move allowed him to live out the principles he espoused in a book he authored in 1895 titled *God's Revenue System*. In this book, Pettiford advocated for economic principles like homeownership and savings among those in the black community. He called on blacks at the time to both patronize black-owned businesses and to aspire to own businesses themselves.

The Alabama Penny Savings Bank opened in October 1890, with working capital of $2,555. *Birmingham Public Library.*

Planting the Seed

Pettiford was born to free parents, William and Matilda Pettiford, in Granville County, North Carolina, in 1847. He lived on a small farm during his young years and received little education. He was described as "an ambitious and hard working minister" in a short biography written in 1887 by Reverend William J. Simmons. He was baptized in 1868 and became clerk at the Pleasant Grove Church in 1869. He was married to Mary Jane Farley—the first of three marriages over his lifetime. Pettiford and his first wife moved to Alabama in 1869 when he was twenty-two years old. He was looking for work, higher education and financial opportunities.

Pettiford lost his wife shortly after they moved. She died in 1870, after only about eight months of marriage. With no family nearby, Pettiford decided to focus on his education and entered the State Normal School in Marion, Alabama. He later attended Selma University, where he studied theology and started to preach part time. While studying, teaching and preaching, he held down any number of part-time jobs over the years to help pay his

In 1915, the Alabama Penny Savings Bank closed, and the building, once a home to many black-owned businesses in the city, was sold to the Grand Lodge of the Knights of Pythias, a fraternal and secret society. *Claire Vath.*

expenses. In 1873, Pettiford married Jennie Powell. She died just a little over a year later in 1874. In 1880, Pettiford left his post as teacher and theological student at Selma University to become pastor of the First Baptist Church of Union Springs. That year he married again, this time to Della Boyd.

In 1883, Pettiford became pastor of the First Colored Baptist Church of Birmingham, later to be renamed the Sixteenth Street Baptist Church. Pettiford's leadership role at the historic church would be short-lived, but during that time he helped right the church financially, getting it out of debt. Reports say that the church owed some $500 when Pettiford became pastor. By 1884, the debt was gone and Pettiford had raised a building fund. On August 18, 1884, the first stone for the new church was laid, and by November services were being held there. Church membership went from about 150 to 425 during that short time. It was clear early on that Pettiford had a head for finance, and he proved himself reliable and honest in all of his dealings as he focused on helping the community grow, not just spiritually but economically as well.

Pastor to Banker

In the late 1880s, there had been a measure of success in other communities throughout the South in setting up banks for the black community. A group of black businessmen from Richmond, Virginia, began to discuss opening such a bank in Birmingham. Pettiford, along with some of Birmingham's most respected black businessmen, felt that someone from their own community should head up any efforts to start a bank, not a group of outsiders.

According to most reports, it took about three months for these businessmen to gain enough community support for the idea to move forward. There was a healthy measure of distrust of black-run banks, as the Freedmen's Savings and Trust Company (commonly called the Freedmen's Bank) had failed, closing in 1874 after fewer than ten years in business. The bank,

started after the Civil War, was aimed at encouraging free blacks to save money, even electing former slave Frederick Douglass as chief officer of the bank to create confidence. The bank never did that well, and once it started loaning money in 1870, bad debts collapsed the already tenuous institution. It was against this backdrop that Pettiford, and contemporaries like Booker T. Washington, worked to create enough momentum to move ahead with their goal of a black-owned bank in Birmingham.

Pettiford, while wholly behind the idea of a bank, did not seem to want to take the great leap and head up the enterprise. He was, after all, a pastor and not a banker. But he seems to have been given very little choice in the matter. The directors of the institution essentially told Pettiford that he would head up the new bank or there would not be a bank. They felt strongly that his name and reputation were necessary to lend public confidence to the institution. Pettiford agreed to take the role for one year. After that he agreed to one more year. As time passed, it became clear to Pettiford how critical his role was, and he stayed for some twenty-three years at the post. Even while holding the job for all those years, he would still continue to preach.

Other leaders who helped promote the idea of a bank in the black community included Peter F. Clark, who would serve as vice-president; B.H. Hudson Sr., who would be a cashier; N.B. Smith; Arthur H. Parker; J.O. Diffay; and Thomas W. Walker. Once the bank was established, the board of directors would include Reverend J.I. Jackson, Professor F.S. Hayzel and Reverend J.Q.A. Wilhite.

It was October 15, 1890, when the Alabama Penny Savings Bank opened for business downtown, at 217 Eighteenth Street North. The sale of stock in the company prior to the opening had generated $2,000. Add to that a deposit on opening day of $555 and working capital for the new bank was just $2,555. It took five years for the bank to be incorporated. This occurred when the Alabama Penny Savings Bank reached the $25,000 mark in cash assets necessary by state law to incorporate a bank.

By 1900, the Alabama Penny Savings Bank was a cornerstone in the community. In a talk that year, Booker T. Washington, a nationally known educator, praised the bank for what it had done for people in Birmingham:

> *I wish to congratulate you among other things upon the excellent and far reaching work that has been done in Birmingham and vicinity through the wide and helpful influence of the Alabama Penny Savings Bank. Few organizations of any description in this country among our people have helped us more, not only in cultivating the habit of saving, but in bringing to us the confidence and respect of the white race...The people who save*

money, who make themselves intelligent and live moral lives, are the ones who are going to control the destinies of the country.

Pettiford was a member of Booker T. Washington's Business League, and in that capacity he helped organize the National Negro Bankers Association in 1906. He was president of the association until his death. The organization's written purpose was "to foster and encourage the establishment of banks among our people and to look after the interest and welfare of those already established."

One road to advancement that both Pettiford and Washington supported drew criticism from some in the black community. Both men, while they emphasized self-help and racial solidarity, were not against the idea of building partnerships with powerful white business leaders and political figures. Pettiford, for example, used his associations with white banks to get training for the Alabama Penny Savings Bank staff in bookkeeping and banking procedures. Records suggest that support from Steiner Brothers Bank helped the Alabama Penny Savings Bank survive an economic crisis in 1893, when several other banks in the community failed.

Years of Growth

Under Pettiford's management, the bank grew and even expanded to other areas in the state. Records show that in 1902 deposits at the Alabama Penny Savings Bank stood at $78,124.21. By late 1911, they were at $421,596.51. The economic success of the Alabama Penny Savings Bank was due to more than deposits. Pettiford and the bank's board looked for financial opportunities to grow the bank, and they found those opportunities in the city's real estate market. Land prices in Birmingham were booming, and the bank's leaders became adept at purchasing fairly large blocks of real estate, subdividing them and selling the lots for houses. While the philanthropic goal behind the real estate purchases was to motivate black families to own homes and build neighborhoods, it was clearly an astute business move, too. The Alabama Penny Savings Bank loaned many of the buyers the funds needed to acquire the property, thereby not only profiting from the sale of the land but from interest on the loans, as well.

As the Alabama Penny Savings Bank grew in strength, branches sprang up in Selma, Anniston and Montgomery. In 1913, the Alabama Penny Savings Bank constructed its own building in the city's thriving business district and moved from its original spot just down the street. Black-owned

Windham Construction built the new six-story building at 310 Eighteenth Street. It's thought that the style of the building is likely that of African American architect Wallace Rayfield. There is good anecdotal evidence, as Rayfield was one of the building's tenants. The building included a good bit of rental space, most of which was used by other black businesses, including the *Birmingham Reporter*, the *Birmingham Messenger* and the *Voice of the People*. It is reported that the Alabama Penny Savings Bank received $8,000 in rent and was a visible example of African American businesses working together to support one another both financially and socially.

By 1914, the Alabama Penny Savings Bank was the largest, financially strongest African American–owned bank in the United States. The bank did business in excess of $500,000 at that time. At one point there were as many as ten thousand depositors across Birmingham and the bank's branches. At this pinnacle of its success, the Alabama Penny Savings Bank lost its president and founder. Pettiford died at age sixty-seven.

The Loss of a Leader

Things took a bad turn for the Alabama Penny Savings Bank in 1915. The bank failed that year, and stories differ as to the details. Essentially there were insufficient funds to cover a run on the bank. The Alabama Penny Savings Bank merged with the black-owned Prudential Savings, becoming the Alabama Penny-Prudential Savings Bank. J.O. Diffay was acting president at the time.

By most accounts, Pettiford's death one year earlier in 1914 had undermined confidence in the bank. Many think that without the alliances he had built in the white banking community there was nowhere to turn when funds were needed to carry the bank through challenging times. The Alabama Penny Savings Bank and all of its assets were sold at the time of the merger with Prudential, including the building. It was valued at more than $150,000, but because of the need to liquidate quickly it sold to the Grand Lodge of the Knights of Pythias for less than half that—$70,000. The Knights of Pythias was, and still is, a fraternal and secret society founded in 1864. The order has over two thousand lodges in the United States and around the world, with a reported membership of more than fifty thousand. The building became known as the "Pythian Temple."

The Alabama Penny Savings Bank building is located at 310 Eighteenth Street North in Birmingham's civil rights district. The bank became the Pythian Temple and was added to the National Register of Historic Places in 1980.

SIXTEENTH STREET BAPTIST CHURCH

On April 3, 1963, African American demonstrators stepped out of Birmingham's Sixteenth Street Baptist Church and marched through downtown, attempting to get service at white-only lunch counters. One month later, on May 2 and 3, children's marches in support of desegregation took place downtown. Those small, brave protestors also stepped out from the doors of the Sixteenth Street Baptist Church. They were arrested as Reverend Martin Luther King Jr. watched. More than two thousand children went to jail during that protest, some as young as six.

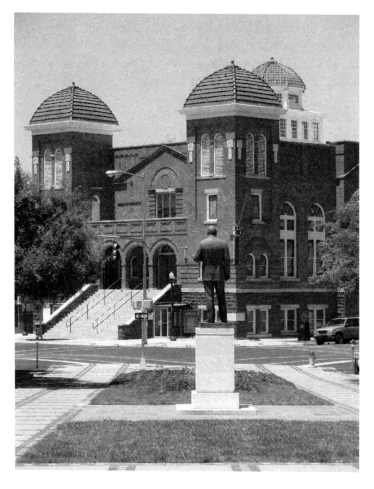

In this current-day view, a statue of Martin Luther King Jr. stands in Kelly Ingram Park, looking across at Sixteenth Street Baptist Church. King feared that the church bombing would lead to what he called "racial holocaust." *Victoria G. Myers.*

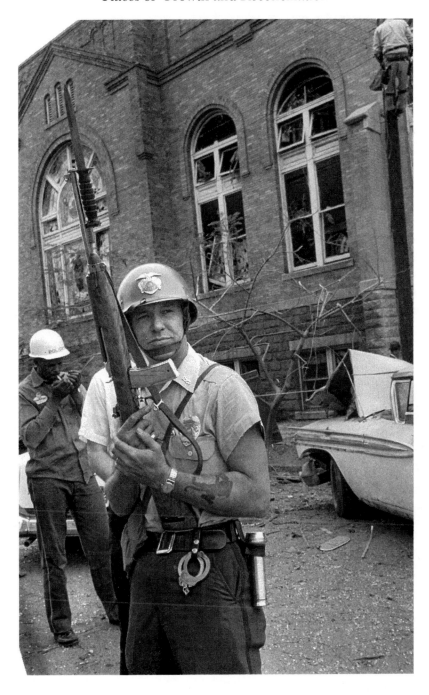

After a bomb exploded at Sixteenth Street Baptist Church, violence between blacks and whites erupted in the streets. *Birmingham Public Library.*

The fact that so much of the civil rights movement in Birmingham was tied to the city's African American churches was bound to make them targets for violence. On September 15, 1963, that violence escalated, taking four young lives and scarring the face of the city forever.

Reverend John H. Cross was pastor of the Sixteenth Street Baptist Church on that Sunday in 1963. In a newspaper report, he recalled that the Sunday school lesson for the day was titled "The Love that Forgives." He was teaching the women's Bible class in the sanctuary when he heard the explosion. "It sounded like the whole world was shaking, and the building, I thought, was going to collapse."

Reverend Cross was right, the whole world was shaking. News of the murder of four young girls rocked the country and the world. At 10:22 a.m. a bomb had exploded, injuring twenty-three people and killing four young girls changing into their choir robes in the church basement. A fifth girl was also in the basement, though she survived. The girls who died that day were Denise McNair, eleven; Addie Mae Collins, fourteen; Carole Robertson, fourteen; and Cynthia Wesley, fourteen.

When the bomb exploded on September 1963, the force was so powerful that it blew out all the stained-glass windows in the church, except one that depicted Jesus knocking on a door. That window was left oddly intact, except for the missing face of Jesus. *Claire Vath.*

Sixteenth Street Baptist Church has a long, proud history in Birmingham's African American community. It was established in 1873 and during the civil rights movement became an unofficial headquarters for many marches and planning meetings. *Claire Vath.*

Sixteenth Street Baptist Church had experienced bomb threats before. But this time any threats that may have been called in were not acted on by authorities, and it seems clear that church leaders were not aware of any danger or they would have cleared the church of innocents. Instead, on a Sunday morning, when the church would clearly be full of parishioners, an explosion blew a hole in the east side of the church. The dynamite was by all accounts attached to some sort of timing device and placed under a set of stairs on the side of the church. Estimates put the number of sticks of dynamite used at about fifteen. The force shattered windows, walls and doors. One stained-glass window was left, a depiction of Jesus knocking on a door. His face was blown out, but the rest of the window was intact. The blast was so strong that it blew out windows in a laundromat across the street.

The bombing reverberated into the streets, with violence erupting between blacks and whites. Several young blacks were shot by police that day. The black community's anger was explosive, and fear and tension were palpable. No one knew where the violence would end.

The UPI news service reported that Reverend Martin Luther King Jr. wired President John F. Kennedy from Atlanta to say that he was going to Birmingham to plead with the black community to "remain non-violent." But he added that unless "immediate Federal steps are taken [there will be] in Birmingham and Alabama the worst racial holocaust this nation has ever seen." In 1963, when this report was written, the UPI said that the bombing was the twenty-first in the city in eight years and the first to kill. The city had acquired the moniker of "Bombingham" for all of the violence. The bombings seemed mostly aimed at black neighborhoods and businesses—or those in the white community who had publicly come out in support of desegregation.

The four little girls were mourned around the country and the world. A funeral for three of the girls (one girl's parents chose to have a private service) was witnessed by eight thousand mourners. Reverend Martin Luther King Jr. gave the eulogy. The tragedy pushed the nation toward progressive, landmark legislation including the Civil Rights Act of 1964 and the Voting Rights Act of 1965.

Because the girls were so young, biographical information is fairly stark. Here are some of the things they are remembered for:

The youngest girl, Denise McNair, was born on September 17, 1951. Her parents were Chris, a photo shop owner, and Maxine, a schoolteacher. Her friends called her "Niecie." She attended Center Street Elementary School, was a member of the young Girl Scouts group, the Brownies, and liked to play baseball and hold tea parties.

Cynthia Wesley, fourteen, was the adopted daughter of Claude and Gertrude, both teachers. She was born on April 30, 1949. Cynthia's mom made all of her clothes because she was so petite. Cynthia went to Ullman High School and was remembered as being good in math, reading and band.

Carole Robertson, also fourteen, was born on April 24, 1949. She was the third child of Alpha and Alvin. Her dad was a bandmaster at a local elementary school and her mom a librarian and musician. Carole was a "straight A" student at Parker High School, where she was a member of the marching band and the science club. She was also a Girl Scout. After her death, her family created the Carole Robertson Center for Learning in Chicago, a social service group for children and their families.

Addie Mae Collins, born on April 18, 1949, was also fourteen when she died. She was the daughter of Julius Collins and one of seven children. Her dad was a janitor and her mom a homemaker. Addie Mae's sister was also in the basement at the time of the blast. She was seriously injured, losing an eye.

A Slow Justice System

Early on, the Federal Bureau of Investigation (FBI) pointed to four men as the likely suspects in the Sixteenth Street Baptist Church bombing. They were Robert Chambliss, Bobby Cherry, Herman Cash and Thomas Blanton Jr. The Birmingham FBI recommended prosecuting these four men for the girls' murders. FBI director J. Edgar Hoover blocked the prosecution, and in 1968 the FBI closed the case. It was reopened in 1971 by Alabama Attorney General Bill Baxley. On November 18, 1977, Robert Chambliss was convicted of murder and sentenced to life in prison. He died there in 1985 at age eighty-one. One of the witnesses against Chambliss, who had the nickname "Dynamite," was his own niece, Elizabeth Cobbs. She later wrote a book about her experiences, *Long Time Coming*. Cobbs said that Chambliss was a member of a Ku Klux Klan splinter group that called itself the "Cahaba Boys."

Of the other suspects, Frank Cash died in 1994 before a case was established against him; Blanton was tried, convicted and sentenced to life in prison in 2001; and Cherry was ruled mentally incompetent until 2002, when he too was found guilty of murder and sentenced to life in prison. As of this writing, all of the men except Blanton have died.

A Proud History

Sixteenth Street Baptist Church has long been a central part of Birmingham's black community. It was the first house of worship for African Americans in the city. Established in 1873, the church was initially called the First Colored Baptist Church. Services then were located in a building at Twelfth Street and Fourth Avenue. In 1880, the church moved to its location at Sixteenth Street and Sixth Avenue.

To date, there have been sixteen pastors over the church's history, including Reverend William Pettiford, who left the post in 1890 to head up the Alabama Penny Savings Bank. He was credited with getting the church out of debt and raising a building fund. In 1884, Pettiford oversaw the first stone for the new church laid and helped build membership past the four-hundred mark.

A few decades later, leaders were ordered to tear down the aging building. Church officials hired the state's only black architect, Wallace Rayfield, to design a new church. The design cost $26,000 to build, and it was finished in 1911. The look of the church was quite unique at the time, described as a modified Romanesque and Byzantine design. It included twin towers with pointed domes and a cupola over the sanctuary. The new church included a sanctuary, a basement auditorium and rooms for church activities and Sunday school classes.

By the 1960s, Sixteenth Street Baptist Church had become a sort of headquarters for desegregation and voting rights protests in downtown Birmingham. It was also an unofficial meeting place for the Southern Christian Leadership Conference and the Congress of Racial Equality. The church paid a heavy price for being such a visible symbol of the civil rights movement.

After the 1963 bombing, more than $300,000 was contributed from around the world to restore the damaged church. It reopened for services on Sunday, June 7, 1964. A special memorial gift, a large stained-glass window of the image of a black crucified Christ, was given to the church by the people of the country of Wales. It was designed by John Petts and is now located at the rear center of the church on the balcony level.

Sixteenth Street Baptist Church embarked on major restoration of the building due to ongoing water damage. The work included the re-creation of the church's historic neon sign and a memorial plaque at the location of the 1963 explosion. Money for the work came through $3.8 million in donations from individuals and corporations. Today this is an active church with many ministries, including one focused on drug counseling for the community.

Sixteenth Street Baptist church sits at Sixteenth Street and Sixth Avenue. Sixteenth Street Baptist church has about 200 members today. More than 200,000 people visit this church every year. The church became a national historic landmark in 2006. Visitors are welcome to the church; among the things to see is a plaque honoring the four girls murdered in the bombing.

KELLY INGRAM PARK

"Don't worry about your children who are in jail. The eyes of the world are on Birmingham. We're going on in spite of dogs and fire hoses. We've gone too far to turn back." Those words were spoken by Reverend Martin Luther King Jr. on May 3, 1963, after more than one thousand children had been arrested for peaceful demonstrations in Kelly Ingram Park.

Today if there is one place in Birmingham where the spirits of civil rights activists still walk, it has to be Kelly Ingram Park in the middle of downtown. While this park has a tumultuous history, its beginning was pretty ordinary as parks go.

In the Beginning

A four-acre expanse in the middle of Birmingham, the park is bordered on the east and west by Sixteenth and Seventeenth Streets and on the north and south by Sixth and Fifth Streets. In 1932, the park was named in honor of local firefighter Osmond Kelly Ingram. Born in Pratt City, Alabama, Ingram joined the navy in 1903 and served on the USS *Cassin*. During World War I, the *Cassin* was attacked by a German submarine while off the coast of Ireland. It was October 16, 1917, and Ingram was scrambling to jettison ammunition. He was a gunner's mate first class. A torpedo attack knocked Ingram overboard, and he became the first U.S. Navy soldier killed in the war. He was awarded the Medal of Honor, and the story of the *Cassin* became known around the world.

Gathering Storms

By 1963, Kelly Ingram Park was a far different place than it had been in 1932. In three decades Birmingham had seen enormous growth and hardship. It was probably the most segregated city of its size in America.

In 1960, the population here was about 350,000—65 percent white and 35 percent black. Jefferson County, where Birmingham is located, still legally required segregation in most areas. Only 10 percent of the city's black citizens were registered to vote. Average income for blacks in the city was half that of whites, and the unemployment rate was at least double. It was during this period that Birmingham gained the nickname "Bombingham" due to a large number of racially motivated bombings across the city. In neighborhoods in which both blacks and whites lived, the bombings were worse. Black churches were frequent targets. Even white city officials who tried to ease or abolish segregation legally were targeted.

At the root of the movement for social change were two leaders in the African American community, one from Birmingham and one from Atlanta. Eventually, the two men would need each other to move their cause ahead.

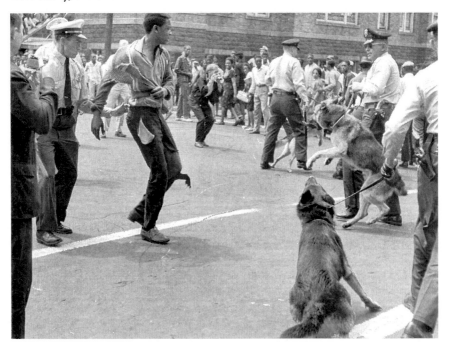

As the jails filled up with young protestors, Birmingham's commissioner of public safety, Eugene "Bull" Connor, ordered the use of police dogs to dispel the crowds. *Birmingham Public Library.*

Places of Growth and Reconciliation

Above: Snarling dogs created by sculptor James Drake line a walkway in Kelly Ingram Park today to help re-create the fear marchers experienced in the 1960s. *Victoria G. Myers.*

Below:A limestone sculpture by artist Raymond Kasky depicts three ministers, John Thomas Porter, Nelson Smith and A.D. King, kneeling in prayer in one corner of the park. It is meant to recall Palm Sunday 1963, when ministers led two thousand marchers as they protested the jailing of civil rights leaders. *Claire Vath.*

Statues of children hugging a wall as a high-powered fire hose is aimed at them recall the bravery of civil rights protestors who refused to run away. *Victoria G. Myers.*

In Birmingham, Reverend Fred Shuttlesworth had formed the Alabama Christian Movement for Human Rights. This group was created after the state outlawed the National Association for the Advancement of Colored People (NAACP). Shuttlesworth and the ACMHR were focused on eliminating segregation in the city, but at every victory they were met with more hatred and new challenges. For example, when they challenged Birmingham's segregation of its city parks and won, the city responded by closing the public parks to everyone. Shuttlesworth was arrested and jailed many times for being so outspoken, and his home was repeatedly bombed, as was his church, Bethel Baptist Church.

In Atlanta, a young Reverend Martin Luther King Jr. was heading up the Southern Christian Leadership Conference. In 1962, King led a movement in Albany, Georgia, to change that city's segregation policies. It was pretty much a flop, and many felt that it had hurt King's reputation. But the lessons learned were going to be put to good use when Shuttlesworth asked him to come to Birmingham. Here King would find what he really needed to succeed—a loud, unlikable adversary who would draw national attention to the fight. That adversary was Birmingham's commissioner of public safety, Eugene "Bull" Connor. President John F. Kennedy later said of Connor, "The Civil Rights movement should thank God for Bull Connor. He's helped it as much as Abraham Lincoln."

The Children's Movement

Connor would be the man responsible for calling out the use of high-pressure fire hoses and police dogs to squelch a series of nonviolent marches mostly

made up of children. He had a reputation for driving around town in a white tank. His militant, racist demeanor gave the media something with which to sensationalize and symbolize the face of southern prejudice.

When the marches began, onlookers were taken aback by the age of many of the protestors. They were young children, often linked arm in arm, singing as they walked through the downtown area. Some reports say that children as young as six were taken to jail as the marches played out. *Time* magazine dubbed this movement the "Children's Crusades." Mary Moore was there. A student at Carver High School, Moore gave an oral history of her remembrances of the marches in 2006. Here are some of her memories, in her own words:

> *During that time most of our parents were afraid. The rationale was that when their bosses learned that they were participating in the movement, then they were fired. In many cases the parents would encourage the children to go to the movement…There were many of us at night, after school, we walked from one side of this city to the other trying to get to a movement meeting. Then once the decision was made by Dr. King that it would be better to use children to take the movement to the next step—and I always remember that night. Because after the decision was made…Dr. King asked the adults, "Why don't you step back and let the children come forth?" His message that night was to the children.*

The children of the community took King's message to heart, and by sheer numbers and determination they would break the back of segregation in Birmingham. And it would climax in a little park, in the center of downtown.

May's Littlest Marchers

The month of May 1963 would be one of the most important in civil rights history. Starting on May 2, with the beginning of the Children's Crusade, and continuing on to May 8, when most of the protestors' demands were agreed to, it was a month that would reverberate for generations. Here is a day-by-day account of some of what happened in a little more than one momentous week in Birmingham:

May 2, 1963, was a Thursday. On this day, more than 1,000 students skipped school and gathered at Sixteenth Street Baptist Church. They

were broken into smaller groups and told to march until they were arrested. There are reports that they sang hymns and freedom songs as they marched. Bull Connor and the police used school buses and paddy wagons to take the children to jail. The fire department was called to bring in trucks to block city streets. By the end of the day, the number of jailed protestors was at 1,200. The Birmingham jail's capacity was 900. Mary Moore remembered, "We quietly got up, left the school, proceeded to downtown Birmingham. And mind you, it was already determined that some children would be arrested. That was already decided. Some would be arrested, some would just keep the marches going. People like my brother got arrested two or three times." The marches were front-page news around the country.

May 3 was a Friday. The Birmingham jail was full. Bull Connor changed tactics to try to stop the protests and the arrests. When another one thousand students gathered at the church and began to walk across the park, they were told to go back by police. When they continued, Connor ordered the city's fire hoses turned on them. It was reported that the pressure on the hoses was set to a level that ripped shirts off and pushed people over the tops of cars. Violence began to beget violence. The adults who had been cheering on the young protestors began to throw rocks and bottles at the police. At this point, Connor ordered the use of police dogs against the crowd. The events of the day were breaking news now around the world.

May 4 was a Saturday. The idea of a nonviolent protest seemed to have been abandoned by everyone. People were taunting the police, while the SCLC leaders begged them to be peaceful. The jails were so full that Connor turned the stockade at the state's fairgrounds in Birmingham into a makeshift holding facility for protestors.

May 5 was a Sunday. Blacks across the city began to arrive at white churches to attempt to integrate services. They were accepted in Roman Catholic, Episcopal and Presbyterian churches. At others they were turned away. Many knelt and prayed until they were arrested.

May 6 was a Monday. The city was on the brink of collapse due to the huge numbers of jailed protestors. Reports say that it took more than four hours to distribute breakfast to the prisoners. Pickets sprang up across the country in sympathy for the jailed.

May 7 was a Tuesday. As protests continued in Birmingham, fire hoses were used again. Reverend Fred Shuttlesworth was injured, along with several police officers. Another 1,000 people were under arrest now, bringing the total to more than 2,500. The governor of the state sent state

troopers to help Connor. Despite their efforts, the protests built until more than 3,000 people swarmed over the streets, sidewalks and buildings in the downtown area.

May 8 was a Wednesday. White business leaders agreed to most of the protestors' demands. Politicians held firm.

May 10 was a Friday. Reverends Martin Luther King Jr. and Fred Shuttlesworth made a public announcement that an agreement had been reached with the city to desegregate lunch counters, restrooms, drinking fountains and fitting rooms within ninety days. They said that blacks would be hired in stores as salesmen and clerks and that those in jail would be released on bond or their own recognizance.

May 11 was a Saturday. A bomb exploded at the Gaston Motel, near the room where Martin Luther King Jr. had stayed earlier. Another bomb went off damaging the house of Reverend A.D. King, the brother of Martin Luther King Jr. When police investigated, they were pelted with rocks and bottles.

May 13 was a Monday. More than three thousand federal troops were deployed to Birmingham to restore order. Bull Conner was reported to say, "This is the worst day of my life."

Kelly Ingram Park is located across the street from both the Sixteenth Street Baptist Church and the Birmingham Civil Rights Institute. Visitors to the Birmingham Civil Rights Institute can get a headset for a walking tour of Kelly Ingram Park. The park includes sculpture highlighting the protests that took place here in 1963, as well as a circular walk called the "Freedom Walk." For more information on Kelly Ingram Park or the walking tours, go to the website for the Birmingham Civil Rights Institute at www.bcri.org or call the institute at 205-328-9696.

A.G. GASTON MOTEL

Like almost all of A.G. Gaston's entrepreneurial ideas, the decision to build a motel was based on a need he saw in the community. During segregation in the South, black visitors to Birmingham had a need for a first-class place to stay. That need was met with the construction of the A.G. Gaston Motel and its opening in 1954. Gaston, who already had an impressive list of businesses around the city, couldn't have known that he was building more than a motel.

He was building a launching point for many of the city's civil rights protests during the volatile 1960s.

The fact that Gaston's motel held such a central spot in the civil rights movement almost seems counter to how this self-made millionaire lived his life and the beliefs he espoused. While Gaston encouraged those in the black community to register to vote and to save their money, he did not seem comfortable with mass demonstrations or with being outspoken or militant. His background was a simple one, where hard work and looking for ways to fill a need when he saw it were the keys to success.

Humble Beginnings

A.G. Gaston was born on July 4, 1892, in the small town of Demopolis, Alabama. His early childhood was spent with his grandparents, who raised him while his mother worked as a family cook for the Jewish family of A.B. Loveman. The family lived twenty-five miles away from Demopolis, so Gaston's mother visited when she could. When Gaston turned thirteen, the Loveman family decided to move to Birmingham to run the state's largest department store. Gaston's mother went with them and so did he. This move gave Gaston a chance to get an education at Tuggle Institute, a private school for African Americans founded by Carrie Tuggle in 1903.

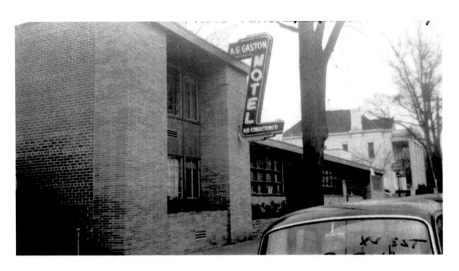

When the Gaston Motel opened in Birmingham in 1954, it was the only first-class motel in the city for African American visitors. *Birmingham Public Library.*

A.G. Gaston was a businessman who realized early on that the key to his financial success was found in serving the needs of others. *Birmingham Public Library.*

Gaston's move to the big city of Birmingham, which even then had a reputation as being dangerous, was something that made a lifelong impression. He recounted the train ride into the city that first day in a book on his life by Dorothy Swygert called *A.G. Gaston: Portrait of a Dream.* He said he remembered being scared and making a pledge to himself: "You, Arthur George Gaston are one colored boy who will not fall into bad company, or get in trouble, or get himself killed." He would remind himself of that pledge many times throughout his life, and it helped him hold to the road that built his fortunes.

After he completed a tenth grade–level education at the Tuggle Institute, Gaston found little opportunity in Birmingham. He enlisted in the U.S. Army in 1913 looking for some excitement and a regular income. Like Birmingham, the armed forces were segregated at the time. Gaston was assigned to the all-black Ninety-second Infantry Division and was eventually deployed overseas to France. The division saw combat in World War I. One of the things Gaston recalled in his later years was how, to him, the French seemed colorblind—there was no notice whether a soldier was black or white. Having grown up in the South, this helped Gaston see the world in a totally new way.

Looking for the Need

When Gaston returned from the war, he found that very little had changed. Jobs were still scarce, and despite an education that exceeded that of most young black men, he wound up doing hard, manual labor at the Tennessee Coal and Iron Company in Fairfield for $3.10 a day. It was not the sort of

job he had hoped for, but it didn't last long. It was here where Gaston started looking for ways to fill the needs of others—for a price.

Gaston had always been a saver, choosing to live a conservative lifestyle so he could put back some of his earnings whenever he had work. But he soon noticed that most of his co-workers lived from payday to payday. When a friend asked him for a loan to impress a girl and buy her dinner, Gaston realized that he could make money by extending small loans to others. He charged them 25 percent interest. He soon added to that income by selling homemade lunches, banking on his mother's sought-after culinary skills. Later, after being asked to contribute to someone's burial fund, he realized that there was a need for burial service insurance. So young Gaston started selling burial policies under the name of the "Booker T. Washington Burial Society." This was 1923, and it was Gaston's first real business. It would set the stage for all that would follow.

Fees for burial policies were twenty-five cents per week for one, and ten cents per week for each additional family member. Gaston was counting on getting a little ahead before he had to pay for his first burial. But time was not on his side. The new business almost went under when a woman died after he had only collected thirty-five cents from her. He had accumulated just ten dollars at the time. Gaston brought the problem to Reverend S.H. Ravizee of the St. Paul African Methodist Church, where he was active. The Reverend told him that he'd see to it that the burial society was broken if Gaston didn't live up to his promise, regardless of the cost. So Gaston went to James Payne of Fairfield, who operated a funeral home for blacks. Payne agreed to bury the body for seventy-five dollars and that he would take whatever could be collected at the funeral as a down payment with Gaston promising to pay the balance.

A Time of Growth

By standing behind that first burial policy, Gaston created confidence in his burial society and the business continued to grow. Over the years Gaston would be a rarity—a self-made black millionaire. He opened or purchased these businesses, all in Birmingham or nearby: Smith & Gaston Funeral Directors, opened 1931; Booker T. Washington Business College, opened 1939; New Grace Hill Cemetery, purchased 1948; Vulcan Realty and Investment Corp., Inc., opened 1952; A.G. Gaston Motel, opened 1954; Citizens Federal Savings and Loan Association, opened 1957; A.G. Gaston

Building, opened in 1960; Zion Memorial Cemetery, purchased 1975; WENN-FM and WAGG-AM radio stations, purchased 1975; the A.G. Gaston Home for Senior Citizens, opened 1963; the A&G Public Relations Company; and the A.G. Gaston Construction Company, opened in 1986 when Gaston was 94 years old. Some estimates place his fortune at more than $130 million by his death at 103 years of age in 1996. In an article in *Jet* in 2001, Gaston explained his philosophy, saying:

> *Successful businesses are founded on needs. Once a businessman sees a need (a need to the public, not to him, not his need to make money) he is on his way... The most important thing, however, is not how big you become or how much money you make. The important thing is what you do with the money you have. Money is no good unless it contributes something to the community, unless it builds a bridge to a better life. Any man can make money, but it takes a special kind of man to use it responsibly.*

Of all the businesses Gaston tried, there is only one recorded flop. He tried to manufacture, bottle and sell a soda called the "Joe Lewis Punch." The Brown Belle Bottling Company was started in 1946 to make the soda. This was probably the only business Gaston got into that did not truly seem aimed at filling a need, proving to him that his need-based business philosophy was his niche.

A Quiet Leader

During the 1950s and 1960s, Gaston was criticized in some circles for not being outspoken enough when it came to the issue of civil rights. His style was more one of quiet leadership. There is plenty of evidence that he worked throughout his life for equal treatment and always encouraged those in the black community to save and register to vote. Gaston had learned that even in segregated Birmingham money equaled a measure of power. He once threatened to close his account at First National Bank if the "whites only" drinking signs were not removed. They came down. He didn't make a fuss. He didn't carry a sign. But he changed things.

Gaston even helped provide Autherine Lucy with the funds needed, through a job, to be the first black student to register at the University of Alabama. Many in the black community were unaware of all he did behind the scenes. He was criticized, even called an "Uncle Tom" by some

civil rights leaders who favored more confrontational tactics. As the civil rights movement built, Gaston would find himself and his motel in an uncomfortable, very public and ultimately dangerous position.

Birmingham's Reverend Fred Shuttlesworth, a critic of Gaston, wanted to bring the Southern Christian Leadership Conference leaders to the city to organize and lead mass desegregation demonstrations. Gaston was against the move. He was part of a biracial group of Birmingham businessmen who wanted to desegregate the city but in a less public way. They had seen some success with the downtown merchants in 1962 with an agreement they would desegregate their stores. But members of Shuttlesworth's Alabama Christian Movement for Human Rights wanted to see things change more quickly, and they threatened to picket Gaston's motel along with white businesses. Gaston continued to work quietly behind the scenes, and when the SCLC did come to Birmingham to plan a campaign, members stayed at Gaston Motel.

It was spring 1963, and Reverend Martin Luther King Jr. was the leader of the SCLC. He stayed in room 30 of the Gaston Motel, using it as a war room of sorts to plan the next step for the civil rights movement. It was in that room where King and fellow SCLC members decided he would defy a court injunction and submit himself to be arrested and jailed. This was to be a show of solidarity with local protestors. This led to the famous "Letter from Birmingham Jail," in which King laid out a philosophy of racial justice and nonviolent demonstrations. Here is a short excerpt from that long open letter, written April 16, 1963, in response to a statement made a few days earlier by a group of eight white Alabama clergymen:

> *I am in Birmingham because injustice is here…I cannot sit idly by in Atlanta and not be concerned about what happens in Birmingham. Injustice anywhere is a threat to justice everywhere. We are caught in an inescapable network of mutuality, tied in a single garment of destiny. Whatever affects one directly, affects all indirectly. Never again can we afford to live with the narrow, provincial "outside agitator" idea. Anyone who lives inside the United States can never be considered an outsider anywhere within its bounds. You deplore the demonstrations taking place in Birmingham. But your statement, I am sorry to say, fails to express a similar concern for the conditions that brought about the demonstrations. I am sure that none of you would want to rest content with the superficial kind of social analysis that deals merely with effects and does not grapple with underlying causes. It is unfortunate that demonstrations are taking place in Birmingham, but it is even more unfortunate that the city's white power structure left the Negro community with no alternative. In any nonviolent*

campaign there are four basic steps: collection of the facts to determine whether injustices exist; negotiation; self purification; and direct action. We have gone through all these steps in Birmingham. There can be no gainsaying the fact that racial injustice engulfs this community. Birmingham is probably the most thoroughly segregated city in the United States. Its ugly record of brutality is widely known. Negroes have experienced grossly unjust treatment in the courts. There have been more unsolved bombings of Negro homes and churches in Birmingham than in any other city in the nation. These are the hard, brutal facts of the case. On the basis of these conditions, Negro leaders sought to negotiate with the city fathers. But the latter consistently refused to engage in good faith negotiation....So the question is not whether we will be extremists, but what kind of extremists we will be. Will we be extremists for hate or for love? Will we be extremists for the preservation of injustice or for the extension of justice? In that dramatic scene on Calvary's hill three men were crucified. We must never forget that all three were crucified for the same crime—the crime of extremism. Two were extremists for immorality, and thus fell below their environment. The other, Jesus Christ, was an extremist for love, truth and goodness, and thereby rose above his environment. Perhaps the South, the nation and the world are in dire need of creative extremists.

While King sat in jail the crowd began to become more and more dangerous. There was quite a bit of discussion among civil rights leaders about whether it was better for King to stay in jail or be bailed out. They knew that King would calm protestors, and this was exactly what many did not want. Gaston took the matter into his own hands and bailed out King. The move earned him a number of enemies in the black community who felt it had made their protests less effective.

As the name "Gaston Motel" became synonymous with King and his group, it became a more dangerous place. The courtyard at Gaston Motel was where King, Fred Shuttlesworth and others announced a truce with white business leaders and city officials. Two days after the truce was announced, two bombs exploded close to room 30, tearing off most of the front of the motel. That same year, Gaston's home was bombed. No one was injured in either event.

A Page from the Past

The Gaston Motel has been undergoing renovations. It is located at 1510 Fifth Avenue North and is part of the city's downtown Civil Rights District.

Gaston Motel originally had thirty-two guest rooms, some of which were considered "master suites" and could sleep up to seven guests. The rooms were all heated and air-conditioned, providing first-class lodging to blacks during the years of segregation. The motel sits adjacent to Kelly Ingram Park, a four-acre public park in which protestors organized for the civil rights marches of the 1960s, and the Civil Rights Institute.

Gaston Motel is part of Birmingham's civil rights district. The motel is located at 1510 Fifth Avenue North. Gaston Motel opened in 1954. Room 30 is where Martin Luther King Jr. and other civil rights leaders planned some of the city's protests. To find out if Gaston Motel has opened to visitors, contact the Civil Rights Institute at 205-328-9696.

CARVER THEATRE

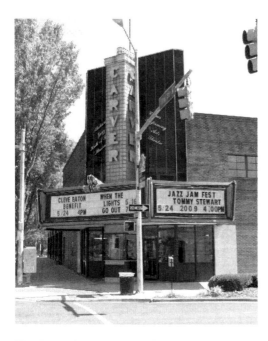

The Carver Performing Arts Center opened as Carver Theatre in 1935. It was the only place in segregated Birmingham to which African Americans could go to see first-run movies. Today it is a center for music education, jazz memorabilia and performances by a variety of well-known artists. *Victoria G. Myers.*

The history of Carver Theatre, today known as the Carver Performing Arts Center, has been repeated in downtowns across America. As people moved out of the cities and into surrounding suburbs, the downtown movie theatre often died a slow, embarrassing death. Birmingham's Carver Theatre is the exception. It was saved as part of a restoration of the city's historical civil rights district and today is a living, active part of the arts community here.

Carver Theatre opened in 1935 on the corner of Fourth Avenue North and Seventeenth Street North. The motion picture theatre was the only place African Americans

The Alabama Jazz Hall of Fame, founded in 1978, was moved to the Carver Performing Arts Center in 1993. Exhibits today focus on music history and greats like charter member Erskine Hawkins. *Victoria G. Myers.*

in this highly segregated city could go to see first-run movies. It was named after George Washington Carver, one of the most revered blacks at this time. Carver had distinguished himself at a time when black researchers and academics were unheard of. Given that Carver was famous as an academic and a horticulturalist, his tie to the arts isn't entirely clear. But there are several old movie theatres that carry the name "Carver" around the country. One can only guess that for developers at the time it seemed like a good drawing card.

What movies were people watching in the 1930s? Some of the most famous of all time. Talkies were already the standard, and after the years of the Depression, Hollywood was in its heyday, providing a form of relatively inexpensive escapism. Musicals were popular, and many vaudeville actors made the leap to the screen. Some of the best-known movies from this time period include *Gone with the Wind*, Disney's *Snow White and the Seven Dwarfs*, *The Grapes of Wrath*, *Stagecoach*, *Tarzan the Ape Man*, *The Wizard of Oz* and *Captains Courageous*. Well-known actors of the day included Shirley Temple, W.C. Fields, Bob Hope, Bette Davis, Greta Garbo, Fred Astaire, Ginger Rogers and the Marx brothers.

In 1945, Carver Theatre went through a big upgrade. The latest in theatre chairs were added, some 1,300 of them. Air conditioning was installed, an absolute blessing in the humid summertime weather of the South. There was also improved sound and projection. At this time, Fourth Avenue was the hub for entertainment in the black community. Unfortunately, time began to take a toll on the theatre. As the decades passed, it went into decline and eventually

wound up showing pornographic movies. This embarrassing chapter of the Carver Theatre's history ended when it was closed in the early 1980s.

A New Life

In the late 1980s, Birmingham's leaders began to recognize how invaluable the city's civil rights district was. There was concern that without renovation some of the city's most prized landmarks would one day be razed for another office building or a parking lot or just be lost to neglect. As part of this movement, Carver Theatre was purchased by the city in 1990, and a remodeling project began to turn it into a place for live performances. The goal was to keep the focus of the new Carver Performing Arts Center on African American history and to make it an ambassador for the civil rights district. The first step in that outreach was the establishment of the Alabama Jazz Hall of Fame within the theatre. The Alabama Jazz Hall of Fame had been founded in 1978 and was moved to this spot in 1993.

The goal of the Alabama Jazz Hall of Fame is defined as a mission

> *to foster, encourage, educate and cultivate a general appreciation of the medium of jazz music as a legitimate, original and distinctive art form indigenous to America. Its mission is also to preserve a continued and sustained program of illuminating the contribution of the state of Alabama through its citizens, environment, demographics and lore, and perpetuating the heritage of jazz music.*

The Jazz Hall of Fame is about 2,200 square feet of exhibit space, focused on the state's rich jazz heritage. There is memorabilia including paintings, quilts, instruments and the personal effects of famous jazz artists. The tour experience is led and made memorable by Dr. Frank Adams, a nationally known musician with close ties to Carver. Adams studied music under John T. "Fess" Whatley and played in Whatley's band for two years. Whatley was known as "Birmingham's Maker of Musicians." Adams had his own band with wife Dot, who was vocalist. He joined the Birmingham Heritage Band in 1976. Adams is a clarinet and saxophone soloist and at this writing is program specialist for music instruction for the Birmingham Public School System. Adams was a charter member of the Alabama Jazz Hall of Fame in 1978. Other charter members include Amos F. Gordon, Erskine Hawkins, Haywood Henry, Sammy Lowe and John T. "Fess" Whatley. New inductees have been added sporadically.

Memorabilia in the Jazz Hall of Fame includes paintings, instruments and the personal effects of many famous jazz artists. *Victoria G. Myers.*

Probably one of the most widely known members of that first group of inductees is Erskine Hawkins, who wrote the classic big-band standard "Tuxedo Junction." This was the most popular song during the World War II era. Hawkins was born in Birmingham in 1914, began playing the drums at age seven and then moved to the trombone. At thirteen he took on the challenges of the trumpet, and that became his instrument of choice. He was a high-note trumpeter with the nickname "the 20th Century Gabriel." Hawkins attended the State Teachers College in Montgomery and led a band called the Bama State Collegians. This group went to New York City during the Depression and made enough money to keep their college afloat during the lean years. The band also played at the Savoy Ballroom. Other hits for Hawkins included "After Hours," "Tippin' In" and "Gabriel's Heater."

Keeping the Music Alive

Today the Carver Performing Arts Center is home to intimate performances by some of the most well-known musicians in the world. Since reopening, the center has hosted artists like Duke Ellington, George Winston and Lionel Hampton. They've also hosted hundreds of students, who participate in the center's educational series or the annual student jazz band festival.

The Alabama Jazz Hall of Fame has a twelve-member jazz faculty made up of music instructors from around the city. Ray Reach is director of student jazz programs. He records and produces classical and jazz records and is director of the Magic City Jazz Orchestra. He directs the Alabama Jazz Hall of Fame All-Stars Jazz Ensemble, made up of faculty members. In addition to Frank Adams and Ray Reach, the Alabama Jazz Hall of Fame All-Stars includes trumpeter and pianist Tommy Stewart; saxophonist Gary Wheat; saxophonist, flutist and clarinetist Dave Amaral; trombonist Chad Fisher; guitarist Carlos Pino; bassist Abe Becker; bassist Cleve Eaton; and drummer John Nuckols.

These artists take their music to the young people, from elementary school students to those in college. A favorite part of the jazz education program is the Saturday Morning with Jazz Greats event. These intensive jazz education courses are free and a hands-on way to continue to offer music enrichment at a time when many schools are cutting this out of the curriculum. The center even coordinates a recycling program for instruments, making them available to those who otherwise would not be able to afford them.

The Carver Performing Arts Center is located at 1631 Fourth Avenue. To see who will be performing at the center or to get more information on educational series, go to the center's website at www.jazzhall.com. The Alabama Jazz Hall of Fame is open Tuesday through Saturday. Both self-guided and guided tours are available; to schedule a tour call 205-254-2731.

Chapter 4

DIVERSIONS

There is a side of adventure and fun to Birmingham that covers an eclectic collection of interests. Whether it's baseball, football, racing or even flying, the diversions Alabamians have enjoyed over the decades are still a part of this city today.

In some cases, like Rickwood Field, these pieces of the past have been lovingly restored so that today anyone can walk onto the same pitcher's mound on which Satchel Paige and Burleigh Grimes once stood. In other cases, the past has been catalogued and spread out across enormous spaces to share with visitors. Want to know more about the Tuskegee Airmen? The Southern Museum of Flight will take you all the way back to that time. Interested in racing? Barber Motorsports Park has one of the best tracks in the Southeast, as well as the world-class Vintage Motorsports Museum. And sports fans will find athletes, coaches and supporters from across the years immortalized at the Alabama Sports Hall of Fame.

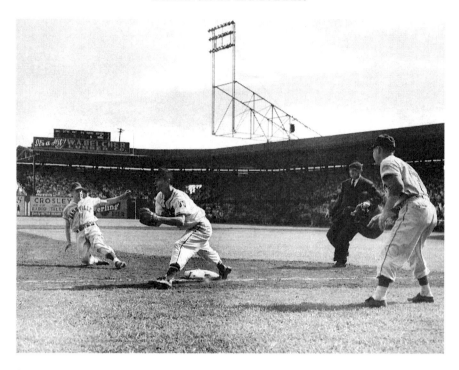

Baseball at Rickwood Field has been a favorite outing for Birmingham families since the park opened in 1910. *Friends of Rickwood.*

RICKWOOD FIELD

Opening day, August 18, 1910—Birmingham's first professional baseball team, the Coal Barons, took to the field in front of a baseball-wild crowd. Businesses all over town had closed for the occasion, and estimates are that some ten thousand people attended the 3:30 p.m. game. The Barons played the Montgomery Climbers and won at a score of three to two after a two-run rally in the ninth inning.

This baseball team and the newly built Rickwood Field were Rick Woodward's babies. Woodward, a millionaire industrialist in the state and chairman of Woodward Iron Company, bought the Coal Barons and then worked with Connie Mack to design what has been described as "the Finest Minor League Ballpark Ever." Mack, a well-known baseball player, manager and team owner, modeled the park after Forbes Field in Pittsburgh and Shibe Park in Philadelphia. Rickwood Field was built at 1137 Second Avenue West in Birmingham.

Woodward, who history suggests secretly wanted to be a professional baseball player himself, threw out the first pitch at the first Barons game at

Birmingham's Coal Barons were a fan favorite. Here team members Billy Bancroft and Shine Cortazzo pose with fans in front of Rickwood Field. *Mrs. Billy Bancroft and Chuck Stewart.*

Rickwood Field. It was not a symbolic pitch; he inserted himself into the game and threw from the mound the first pitch of the game. It was called a ball. He then retired, and the Barons' regular pitcher took his place.

The Coal Barons had been a professional team since 1885 but lacked a true home park at which to play. Prior to the opening of Rickwood, Baron home games were held at a make-do spot known as "Slag Pile Field." The Slag Pile only held about six hundred fans, and use of the land was only granted one sixty-day lease at a time. When Woodward, still in his twenties, bought controlling interest in the Coal Barons team from owner J. William McQueen, he immediately started planning the ballpark. He had the means to indulge his passions as the grandson of Stimpson Harvey Woodward, a pioneer industrialist in Birmingham.

The land for Rickwood Field was purchased from the Alabama Central Railroad. The structure cost $75,000. The park was 12.7 acres in size and included concrete and steel stands. A tile-roofed cupola behind home plate held the announcer and the press. Rickwood was the first concrete and steel ballpark in the minor leagues.

Rickwood Field became home park to two sets of Barons, the white Birmingham Coal Barons and the Birmingham Black Barons. The teams

Ted "Double Duty" Radcliffe played for the Birmingham Black Barons from 1942 to 1946. Born in Mobile in 1902, Radcliffe had a long career in baseball. *Clarence Watkins.*

played on alternate weekends, and sellout crowds for both teams were the norm. Seating at Rickwood was segregated, with designated sections for black fans when the white teams played. The Black Barons were newly formed when Woodward built the park. The team played as an independent until becoming a member of the Negro Southern League in 1920. The Black Barons were the first southern team to enter the Negro National League in 1924. In 1956, the Black Barons entered the Negro American League.

The Black Barons

The Black Barons were one of the most successful teams in the Negro League, winning league pennants in 1943, 1944 and 1949. They lost all three Negro League World Series games to the Homestead Grays of Pennsylvania. As ownership of the team changed over the years, the team sometimes played as a member of the Negro Southern League, the Negro National League or the Negro American League.

Frank Perdue, the first owner of the team, paid $200 in 1920 for the rights to the Black Barons in the Negro Southern League. He was the first president of the league. Owners of the team included Joe Rush and Tennesseans Tom Hayes and Abraham Saperstein. Saperstein also owned the Harlem Globetrotters basketball team and provided off-season income for some of the Black Barons by adding them to the Globetrotters' roster. One Baron, Reese Tatum, was both a center fielder for the baseball team and a well-known Globetrotter who went by the name "Goose" Tatum.

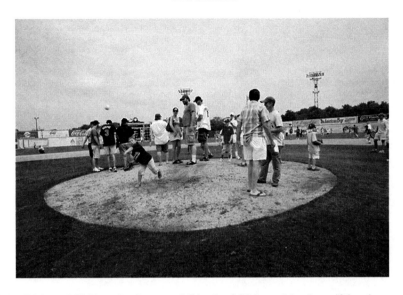

Today Rickwood Field, under the care of Friends of Rickwood, is a beautiful park at which visitors can still see games or throw a pitch from the same spot on which players like Burleigh Grimes or Satchel Paige once stood. *Bill Chapman.*

Interest in the Black Barons was high among blacks and whites. But the black community especially took a great deal of pride in the success of the team. When the Black Barons were playing, preachers would often dismiss the congregation early so they wouldn't miss the game. Many of the players were locals who had played in the streets of Birmingham as children. Often men tried to work for companies that had players in Birmingham's Industrial League, companies like the American Cast Iron Pipe Company, Stockham Valve or the coal companies. Much of the credit for the team's success goes to four team members since inducted into the Baseball Hall of Fame: pitcher Satchel Paige (1927–30), outfielder Willie Mays (1948–50), pitcher Bill Foster (1925) and first baseman Mule Suttles (1923–26).

Leroy Satchel Paige was a rookie pitcher for the Barons. He was the first African American inducted into the National Baseball Hall of Fame in 1971. He pitched more than 2,500 games, with more than one hundred no-hitters. He had a reputation as the hardest thrower in the Negro Leagues.

Willie Mays was inducted into the National Baseball Hall of Fame in 1979. He had 3,283 hits and 660 home runs to his credit and participated in four World Series Games. He had a close connection to Birmingham, having grown up in Fairfield, just thirteen miles outside of the city. His father, William Howard, was a steelworker who played for the Birmingham Industrial League, a semipro team.

Rickwood Field is the oldest surviving professional baseball park in the United States. *Bill Chapman.*

Bill Foster was inducted into the National Baseball Hall of Fame in 1996. He was a southpaw pitcher with a good fastball. He only played for the Barons for one year.

Mule Suttles was inducted into the National Baseball Hall of Fame in 2006. He was the all-time home run leader for the Negro Leagues with 237 homers.

After Jackie Robinson broke into the Major Leagues as the first African American with the Brooklyn Dodgers, the Negro Leagues began to decline. Five players from the 1948 Black Barons team signed major league contracts: Willie Mays, Bill Greason, Artie Wilson, Piper Davis and Jehosie Heard. The Black Barons continued to field teams but played their last season in 1960, the same year the Negro Leagues disbanded.

In the mid- to late 1950s the Black Barons created some interesting trivia for today's enthusiasts. They traded a bus to the Louisville Clippers for the contract of Charley Pride, a pitcher and outfielder in 1954. Pride was a country music singer, who later ended up in the Country Music Hall of Fame. In 1955, the Black Barons finally won the Negro League Championship— but there were only five active teams left in the league. When the league opened the season in 1960, just four teams remained. The league officially disbanded at the end of the year. The Black Barons hung together for two more years as a traveling team that went to local communities and played. They officially disbanded in 1963.

Diversions

The Birmingham Coal Barons

The Birmingham Coal Barons would eventually come to be known as simply the Birmingham Barons. Throughout the team's history, Carlton Molesworth has remained one of the best-known names with the team. Molesworth started playing as an outfielder in 1906 and was also the team manager. He held that post longer than anyone else, from 1908 to 1922. He helped the Barons win two Southern Association titles.

Another early star on the team was Burleigh Grimes, the man who would come to be known as the last legal spitball pitcher in the Major Leagues. Grimes only played with the Barons a couple of years, but in 1915, while with the team, he struck out 158 batters; he won twenty games in 1916 while pitching 276 innings. Grimes was inducted into the National Baseball Hall of Fame in 1964.

The 1920s were a golden age of baseball in Birmingham. The Barons set attendance records, drawing more than 16,000 fans to Rickwood on at least eight occasions. One game in 1927 brought a record 29,915 to the park. This was the year Hall of Famer Rube Marquard pitched for the team. The Barons won the Southern Association title in 1928. The team that year was managed by Johnny Dobbs and had a .331 batting average. They won ninety-nine games that season, a club record.

The 1930s were a challenging time for the Barons. They played some good baseball, but financially the team was hurting. Probably the most memorable game in Rickwood Field's history with the Barons occurred during this period, in the year 1931. The Barons were playing in the Dixie Series, which was like a world series game for the South. The Barons were up against the Houston Buffs out of Texas and their pitcher, Dizzy Dean. Prior to the game Dean started talking down the Barons in the media and created such an uproar that by game day nearly twenty thousand people were at the park. Ray Caldwell pitched for the Barons. At the bottom of the eighth inning, the Barons scored one, and they held on to win the game. Defeating Dizzy Dean, who had insulted their team, was one of the biggest days in Baron history. Despite the strong attachment to the Barons by the fans, the team wasn't doing well financially. Rick Woodward was forced to sell the team to Ed Norton in 1938.

There were some more ups and downs for the team after that. By the mid- to late 1940s, Rickwood Fields was again seeing record crowds watch the Barons play. In 1948, the Barons won the Dixie Series. In 1958, they won the Southern Association pennant. But after the 1961 season, the Southern Association folded, and for the first time in fifty-two years there was no baseball at Rickwood. The park was empty for two years.

In 1964, Al Belcher, who had owned a majority share of the park in 1958, teamed up with Kansas City Athletics owner Charley Finley to bring the Barons back as an AA team in the new Southern League. The general manager of the team, Glynn West, bought one thousand wooden seats from New York's Polo Grounds for Rickwood. Attendance was weak and play was suspended again in 1966. Belcher sold Rickwood Field to the City of Birmingham in 1966 but retained a one-year lease. That lease was transferred to Charley Finley, who brought his Kansas City's AA farm team to Birmingham for the 1967 season, calling the team the Birmingham A's. The A's took the Southern League title that year.

After the 1975 season, the A's moved and the doors to the stadium were closed. For five long years the city would not see Southern League baseball. Then in 1981 Art Clarkson purchased the Detroit Tigers' AA affiliate in the Southern League, the Montgomery Rebels, and moved them to Birmingham. They were renamed the Birmingham Barons, and they played in front of the biggest crowd Rickwood had seen for thirty-one years, about 9,185 fans. They would remain at Rickwood until 1987, when Clarkson decided to move the team to the new Hoover Metropolitan Stadium, which held 10,800 seats.

Keeping Rickwood Alive

Since 1992 Rickwood Field has been under the care of Friends of Rickwood, who have worked to restore the facility while using it for special events. There are period uniforms, vintage signs on the outfield and a drop-in scoreboard. Since 1996, the field has hosted the Rickwood Classic, where the Barons and the visiting team wear period uniforms and play. The field has been the site of several films. As of 2005, Friends of Rickwood had completed $2 million worth of reinvestment in the park. Some of the work has included restoration of the grandstands, press box, locker rooms, roof and main entrance. As work continues a Museum of Southern Baseball is being established, and there's talk of a Negro and Southern Leagues Hall of Fame for the park.

Rickwood Field is located at 1137 Second Avenue West. It is the oldest surviving professional baseball park in the United States. Rickwood Field is open Monday through Friday, but visitors should check the event schedule to be sure the park is accessible. For details on visiting Rickwood, go to www.rickwood.com or call 205-458-8161. For information on the Birmingham Barons team, or its schedule, go to www.barons.com.

Diversions

SOUTHERN MUSEUM OF FLIGHT

From the Wright brothers' first flying school to the inspiration of the Tuskegee Airmen's fighting spirit, there's a lot of aeronautic history in the Deep South and particularly in Alabama. Birmingham's Southern Museum of Flight keeps these memories alive and well, while providing a spot for today's enthusiasts to continue to build on that history.

The museum exists today thanks to the foresight of Mary Alice Beatty, wife and fellow aviator of Donald Croom Beatty. The name "Beatty" is well known among aviation history buffs. Donald Beatty was inducted into the Alabama Aviation Hall of Fame in 1982; he had died two years earlier, still living in the Birmingham area in which he was born. Beatty was a military aviator, air explorer, engineering test pilot, aerospace executive and inventor with several patents to his credit. His first solo flight was in a self-built plane at his grandfather's farm in Tarrant, Alabama. After that he was hooked, and the rest of his life was dedicated to flying in one way or another.

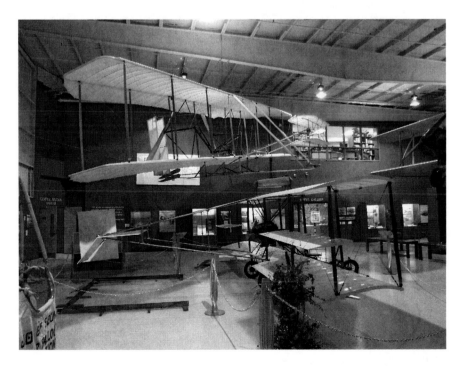

The Southern Museum of Flight traces the history of flight back to the beginning. A full-sized replica of the *Wright Flyer* hangs in the inside exhibit area. The Wright brothers' first flying school was located in Alabama, just outside of Montgomery. *Southern Museum of Flight.*

A special tribute to Alabama's Tuskegee Airmen opened in 2008 at the Southern Museum of Flight. The Tuskegee Airmen were the first African American military airmen in the U.S. Army Air Corps. *Southern Museum of Flight.*

Not long after that first solo flight over his grandfather's farm, Beatty joined the Alabama National Guard air unit as a flying officer in 1922. In the 1930s, he began developing air routes through South America for Pan American Grace Airlines. It was while flying in the Andes that he set up the first system for plane-to-ground voice communications. His concept of reporting in at five-minute intervals using coordinates established a system that helped searchers locate downed planes. He came up with the idea of varying altitudes and routes based on the season.

Beatty's work in South America put him in the company of many famous explorers and led to membership in the Explorers Club of New York, as well as the Royal Geographical Society of London. He earned a medal from the Smithsonian Institution for his work.

While he was an explorer and an inventor at heart, Beatty was also responsible for saving unknown numbers of lives in World War II. Under the code name "Consairway," he established a ferrying system to get bombers into areas all over the war zone. He also pioneered barometric route selecting for long, overwater flights. Many of his contributions were on the communications side of aviation. He built the first voice radio stations in Alabama, which could broadcast weather reports to make flights safer. He held a patent for refining the crystal radio, the first patent on the telephone answering machine, the automatic dialer, the hands-free phone and GAALT, an amplifier used in satellite development. He was even a participant in the design and development of the U.S. Army's first successful helicopter in 1944.

Beatty's wife, Mary Alice, was also an aviator. As such, she recognized the historical significance of what was happening around them regarding

aviation. She began to collect memorabilia and all types of aviation-related artifacts, hoping that one day there would be a museum in which to house them. Thanks to Mary Alice Beatty, the Southern Museum of Flight is today one of the Southeast's largest civilian aviation museums. She had the forethought to know that things like old propellers, pieces of airplanes and even invitations to banquets (like one attended by Charles Lindbergh when he was in Birmingham) would be invaluable.

The museum started at Samford University's library, where the Birmingham Aero Club first installed exhibits in 1965. In 1967, the collection, still growing, moved across from the terminal at the Birmingham Airport into the main lobby of the Birmingham Airport Motel. Two years later, the collection was given its official name, the Southern Museum of Flight. The Aero Club bought land close to the airport in 1976 for a new building. Construction began in 1978, and in 1983 two of the four wings opened. The collections, and the facility, were donated to the city in exchange for an operating budget. Today the museum not only holds the collection started by Mary Ann Beatty but also the Alabama Aviation Hall of Fame, the Flying Heritage Gallery, a model gallery and hands-on exhibits for visitors.

From the Beginning

While the original *Wright Flyer* resides in the Smithsonian's Air and Space Museum in Washington, D.C., a full-sized replica hangs above a display at the Southern Museum of Flight. The Wright brothers' first flying school was located in Alabama, just outside of Montgomery, at what is now Maxwell Field. There is a night light here from their landing field, along with a note from Orville Wright's niece, who flew with him, and a piece of fabric from the Wrights' plane.

The *Wright Flyer* was the first plane to successfully combine the elements needed for flight: lift, propulsion and control while in the air. The Wright brothers used a twelve-horsepower engine powering two propellers and an airfoil shape that created lift while aiding in propulsion. The replica of the *Wright Flyer* at the Southern Museum of Flight was built to mark the 100th anniversary of flight in 2003 by John C. Reynolds of Carnesville, Georgia. It took Reynolds just four years to build the replica. He has loaned it to the museum for display, after taking several trial runs in it himself.

One of the gems, and oldest pieces at the museum, is a Huff-Daland crop-duster. There are only two of these planes left; the one here is completely original. The other, located in the Smithsonian, was pieced together from parts. The Huff-

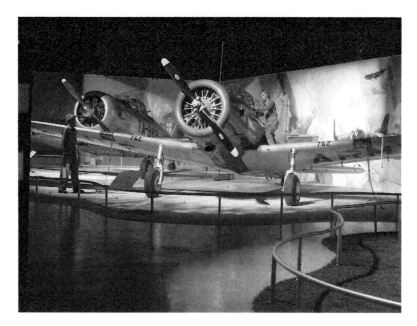

The Southern Museum of Flight has its roots in the collection of aviator Mary Alice Beatty, wife of aviator and inventor Donald Croom Beatty. *Southern Museum of Flight.*

Daland Puffer on display here was the first crop-duster operated by Delta Air Service, later to become Delta Airlines. It was used all over the South, including Alabama, Mississippi and Louisiana, to help control the boll weevil, a pest that threatened to decimate the South's annual crop of white gold, also known as cotton. The idea of using an airplane to apply the pesticide was devised by an entomologist. Prior to this, mule-drawn wagons were used for the job.

Other early aviation pieces on display here include the Curtiss D-4 Pusher, the first model to take off from a ship (the USS *Birmingham*) in 1910; the Alexander Eaglerock biplane, made famous in the 1920s by barnstormers who landed in rural areas and sold rides for fifty cents apiece; and a German Fokker D.VII fighter used in 1918.

Tuskegee Airmen Remembered

Along with tributes to veterans from all of the wars in which America has been involved, there is a special exhibit area set aside for the Tuskegee Airmen. This tribute to the first African American military airmen in the Army Air Corps

opened in 2008. These pilots flew with great distinction during World War II as the 332nd Fighter Group. They were active from 1941 to 1946 and were widely known as "the Red Tails." Their motto was "Spit Fire."

The foundation for the group came from a civilian pilot training program at Tuskegee Institute in Tuskegee, Alabama. The historically black institution was founded by Booker T. Washington in 1881 and had a strong pilot training program going back to 1939. The program was led by Charles Alfred Anderson, thought by many to be the nation's first African American to earn a pilot's license. Prior to the Tuskegee Airmen, there were no black U.S. military pilots. And once established, the group had to be segregated from white units. That meant that not only black pilots were needed, but also black surgeons, navigators and bombardiers. African Americans had never before filled these roles.

The Tuskegee program officially began in 1941 with the formation of the Ninety-ninth Fighter Squadron at the Tuskegee Institute. The unit went to basic training at Moton Field and then moved to Tuskegee Army Air Field, where it was placed under the command of one of the few black West Point graduates in America at the time, Captain Benjamin O. Davis Jr. The Tuskegee Airmen initially flew P-40 Warhawks and then P-39 Airacobras, P-47 Thunderbolts and, finally, P-51 Mustangs.

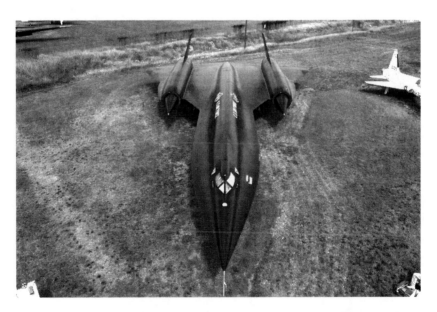

The air park at the Southern Museum of Flight allows visitors to see a wide range of aircraft. Volunteers help with restoration work on all the pieces. *Southern Museum of Flight.*

There were 992 pilots trained in Tuskegee, with about 445 deployed overseas. Estimates are that 150 of these airmen lost their lives in accidents or in combat. They came home with 150 Distinguished Flying Crosses, Legions of Merit and the Red Star of Yugoslavia. The group was deactivated in 1946, but it had made its mark. The Tuskegee Airmen changed perceptions forever about the abilities of African Americans in the military, and in 1948 Harry S. Truman desegregated the United States military.

One of the best-known supporters of the Tuskegee airmen was Eleanor Roosevelt. She visited Tuskegee Army Air Field in 1941 and insisted on taking a ride in an airplane piloted by African American Charles Anderson. Roosevelt asked that photographs be taken of the ride, and she carried them back to Washington to lobby President Franklin D. Roosevelt to activate the airmen for missions in North Africa and Europe. In 1943, the Tuskegee Airmen entered their first combat mission over North Africa.

The Jet Age

The museum recognizes the jet age with a number of exhibits and jets on display. Of note is the exhibit chronicling the defection of a North Korean pilot during the Korean War. The pilot flew to a US F-86 base in 1953. He was twenty-one-year-old senior lieutenant No Kum-Sok. The pilot was flying a MiG-15, the best that the Communist Bloc had. No was awarded $100,000 and allowed to stay in the United States.

Other notable aircraft on display here include a B-25 recovered from Lake Murray, South Carolina. The World War II bomber had been underneath 150 feet of water after the pilot had to ditch. In the South Hall, visitors can see an F-86F Sabrejet, a T-6G Texan, a B-25C Mitchell and a BT-13B Valiant. In the air park there are an A-12 Blackbird from the Lockheed *Skunk Works*, a TF-102 Delta Dagger, a T-37 Tweety Bird, a MiG-21, an S-2 Tracker, an F-104 Starfighter, a Skycrane helicopter and an L-39 Eastern Bloc jet trainer. In all, the museum owns more than ninety aircraft and has nearly one hundred in both indoor and outdoor exhibits. New items are put on display often.

For those who want to get down to the actual nuts and bolts of aviation history, there is an engine collection at the museum that includes jet engines, a Pratt & Whitney J-48 and an Allison TF41-A-2, as well as two dozen piston engines. There are also cutaway engines, one of which runs at the flip of a switch to show how it works. There are home-built and experimental

aircraft, as well as a number of scale models. Volunteers help with all of the restoration work at the museum.

The Southern Museum of Flight is located at 4343 Seventy-third Street North, just two blocks east of the city's airport. To check on museum hours and days of operation, go to its website: www.southernmuseumofflight.org or call the museum at 205-833-8226. The museum offers summer camps and educational programs for young people and their families. About fifty volunteers help with all the restoration work on the museum's projects. To date there are some one hundred different aircraft on exhibit at the museum, in both its indoor and outdoor areas.

BARBER MOTORSPORTS PARK

Whether it's on two wheels or four, there's a world-class surprise waiting for race fans at Barber Motorsports Park. The park, which includes the Barber Vintage Motorsports Museum, is the baby of George Barber. This third-generation Birmingham native has turned his love of racing into both a track and a museum that brings visitors from around the world.

Barber has a long affinity for racing. He modified, raced and maintained Porsches in the 1960s, coming away with sixty-three first-place wins to his credit. In the 1970s, after his father died, Barber had to walk away from his full-time pursuit of racing and take control of the family milk business, Barber Dairies, which dates back to the 1930s. Barber was just thirty when he took the reins of the company. In 1997, Barber's Pure Milk Company was sold to Dean Foods.

Even though Barber wasn't racing Porsches anymore, he still had a passion for high-performance cars. He began collecting and restoring classic sports cars in the late 1980s. It was something that actually started with the remanufacturing of Barber's distribution trucks used in the milk business. As parts got harder to find for the trucks, the mechanics began to work on cars with Barber. Then they turned to motorcycles. That simple beginning got Barber thinking, dreaming, about building a world-class motorcycle collection unlike anything else that existed. And he wanted to do it in Birmingham.

Barber's mission was to preserve motorcycle history in the United States in a unique way—one that would represent the international scope of motorcycles. He wanted to have tangible examples of bikes known to most enthusiasts only through pictures in books or magazines. The work started at a secluded location in the city where a commercial vehicle refurbishing

The Barber Vintage Motorsports Museum is a part of Barber Motorsports Park. The collection opened to the public at its present site in 2003. *Barber Motorsports.*

facility existed. While work was ongoing to build the collection for the museum, a vintage motorcycle race team was operating. The goal was maintaining and racing what were deemed "historically significant machinery." The machines were raced in the United States, as well as Europe, bringing the Barber Team seven national championships in the American Historic Racing Motorcycle Association.

In 1994, the Barber Vintage Motorsports Museum got its official nonprofit foundation status. And on March 14, 1995, the collection was opened to the public in a southern area of Birmingham. The collection stayed there until November 1, 2002, when it was closed so that it could be readied for a move to its new home. It reopened at the new Barber Motorsports Park on September 19, 2003. The 740-acre wooded park is located in the Birmingham city limits, very close to the town of Leeds. The new museum was just one part of the park; it also included a 2.38-mile racecourse. The inaugural Barber 250 sports car race opened the park. The course has sixteen turns and a total elevation change of just over eighty feet. So far two records have been set on the course. One, the fastest lap in a car, was set by Will Power in March 2009. Average speed was 119.213 mph. The other was fastest lap on a motorcycle, set by Mat Mladin in April 2008. Average speed was 115.474 mph.

Above: The mission of the museum is to preserve motorcycle history in a unique way that represents the international motorcycle community. There are more than 1,200 vintage and modern motorcycles and race cars in the collection, many of which have been featured in exhibits around the world. *Barber Motorsports.*

Below: George Barber is the man behind Barber Motorsports Park. He has a long-standing passion for racing, going back to the 1960s when he modified, raced and maintained Porsches. *Barber Motorsports.*

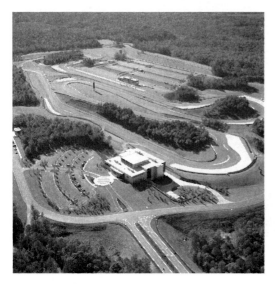

Barber Motorsports Park includes a 2.38-mile racecourse, drawing visitors from all over the Southeast. *Barber Motorsports.*

For race fans, there's something to see almost every weekend. There are even driving schools for those brave souls who want to see how it feels to handle a race car on the track. And while the races draw the crowds, it's the museum that has been described as a work of art.

The Barber Vintage Motorsports Museum has more than 1,200 vintage and modern motorcycles and race cars. The collection is so rare that some of the pieces have been featured in exhibits around the world. Twenty-one motorcycles were used in the Art of the Motorcycle exhibit at the Guggenheim's in New York; at the Bilbao in Spain; and at the Field Museum in Chicago. The Goodwood Festival of Speed in England has featured cars from the collection. Even Birmingham's Museum of Art has held a special exhibit featuring motorcycles from the Barber Collection.

The museum is able to display about half of its collection at any one time, but the exhibits change frequently enough so there is always something new to see. The museum extends over five levels and 141,000 spare feet. The bikes on display range from 1902 models all the way up to current models. There are over two hundred manufacturers represented in the collection and twenty countries. Some of the bikes have come from as far away as Australia, Sweden and New Zealand. The motorcycles are restored as close as possible to original specifications, and visitors to the museum can watch work taking place in the restoration facility. There is a complete machine shop and a fabrication shop so that parts no longer available can be made. Virtually every vehicle here is in running condition.

To help with the creation and restoration of the motorcycles, there is the Barber Vintage Museum Library. Here is one of the largest collections in the world of motorcycle literature, including service manuals, parts catalogues, magazines, books, videos and photos. Race records are also kept here.

Diversions

Barber Vintage Motorsports Museum is also home to the largest collection of Lotus race cars in the world. The forty-three Lotuses here include among them a replica of the first car built, all the way to the last car built. The Lotuses are often demonstrated during race events. Other cars in the collection include a 1964 Ferrari 158 used by Sir John Surtees to win the world championship in 1964.

Barber Motorsports Park is located at 6030 Barber Motorsports Parkway, Birmingham, Alabama. For information on visiting the museum go to www.barbermuseum.org. A schedule of race events is available at www.barbermotorsports.com. Barber Motorsports Park hosts a variety of racing types, including IndyCar, Porsche, Superbike, Sportscar Vintage and more.

ALABAMA SPORTS HALL OF FAME

It's a surprise to a lot of people to find that the state of Alabama has such a rich sports legacy. But whether it's baseball, football, track, boxing or even soccer, there's an Alabamian who has excelled in it. It's also pretty likely that they have been inducted into the Alabama Sports Hall of Fame.

The Alabama Sports Hall of Fame includes more than five thousand sports artifacts in a thirty-three-thousand-square-foot facility. *Alabama Sports Hall of Fame.*

New members are inducted into the Alabama Sports Hall of Fame every year. Nominees are judged not only on their athletic achievements but also on having brought a measure of fame and glory to their home state of Alabama. *Alabama Sports Hall of Fame.*

The Alabama Sports Hall of Fame was created in 1967 by an act of the state legislature. Its purpose was to be a place for the celebration and preservation of the state's great sports heritage. Today it has grown to become a benchmark for other sports museums around the world, with more than five thousand sports artifacts in this attractive thirty-three-thousand-square-foot facility. What makes this hall of fame so special is that it continues to grow, inducting new athletes each year. The Alabama Sports Hall of Fame belongs to the citizens of the state because they nominate inductees. Without that first step, a sports hero doesn't get in no matter how good he or she is. Anyone living in Alabama can nominate a person, living or dead, who he believes through his athletic or sports exploits has brought fame and glory to the state.

Five of the Best

The system works. Today, out of the top fifteen athletes on ESPN's list of the top one hundred athletes of the century, five are also in the Alabama Sports Hall of Fame: Jesse Owens, Hank Aaron, Joe Louis, Willie Mays and Carl Lewis. All of these men had special ties to Alabama, and two of them to Birmingham in particular.

Henry (Hank) Louis Aaron was born in Mobile, Alabama, in 1934. He was inducted into the Alabama Sports Hall of Fame in 1980 and into the National Baseball Hall of Fame in 1982. Aaron was the all-time home run champion with 755, surpassing Babe Ruth's record of 714. During his career he had 3,771 hits and at one time set major league records for total bases, extra-base hits and RBIs. Aaron played for the Milwaukee Braves, the Atlanta Braves and the Milwaukee Brewers. Since 1976 Aaron has been director of player development for the Atlanta Braves.

Joseph Louis Barrow's nickname in the boxing ring was "the Brown Bomber." He was born in 1914 near LaFayette in a tenant's shack on Alabama's Buckalew Mountain. He won the World Heavyweight Boxing Championship in 1937 when he knocked out Jim Braddock. Joe Louis, as he is most commonly known, nearly won the championship in 1936, but he lost to Max Schmeling. He fought Schmeling again in 1938 and scored a KO in the first round. He retired in 1949 with sixty-eight wins and just three losses. Fifty-four of those wins were knockouts. He died in 1981 and was honored by President Ronald Reagan with the American's Award posthumously in 1984. He was inducted into the Alabama Sports Hall of Fame in 1969.

Carl Lewis joined the ranks of Alabama sports heroes officially in 1999, but he had been an inspiration long before that. Born in Birmingham in 1960, Lewis is today one of the best-known Olympians in U.S. history. Over the course of four Olympics he won nine gold medals. His golds included four consecutive wins in the long jump (1984, 1988, 1992 and 1996); two consecutive wins in the one-hundred-meter dash (1984 and 1988); and two wins in the four- by one-hundred-meter relay (1984 and 1992). At the time he won four Olympic gold medals in the 1984 Olympics, he was only the second athlete in history to accomplish this.

Willie Mays, known as "Say Hey Kid," was a baseball hero all the way back to his days at Fairfield Industrial High. Born in 1931, Mays started playing baseball when the teams were still segregated. He was a star player for the Birmingham Black Barons in the Negro American League before moving into the Major Leagues. He was a major league player of the year

in 1954 and most valuable player in the National League in both 1954 and 1965. Mays played professional baseball for twenty-four years. He's been in four World Series and twenty-four All-Star Games. He is fourth in career home runs behind Barry Bonds, Hank Aaron and Babe Ruth. Mays was inducted into the Alabama Sports Hall of Fame in 1977.

James Cleveland "Jesse" Owens was a track star from Danville, Alabama. Born in 1913, he is a 1970 inductee into the Alabama Sports Hall of Fame. Owens set world records in the one-hundred-yard dash, the two-hundred-yard dash and the broad jump. Owens received the Presidential Medal of Freedom in 1976 and the Living Legends Award in 1979. He died in 1980. Owens, son of a sharecropper and grandson of a slave, won four gold medals in the 1936 Olympic Games in Berlin. His outstanding performance is well remembered by many the world over because it so visibly discredited the racist claims of German dictator Adolf Hitler.

Distinguished Sportsmen

Along with the 281 inductees into the Alabama Sports Hall of Fame, there are those who have contributed to sports without necessarily being an athlete. In 1986, a new category was created that isn't about home runs or world records. Called the Distinguished Alabama Sportsman, this award is a way to recognize someone who may not be an athlete but has nevertheless made a major contribution to sports. The hall of fame even recognizes, on occasion, those who are not native Alabamians but have made important contributions to sports. (In this case the honor is called the Distinguished American Sportsman.) Honorees have included people like the University of Alabama's Mal Moore, Auburn University's David Housel, outdoor sportsman and wildlife conservationist George Mann and Lakeshore Foundation founder Michael Stephens.

The Alabama Sports Hall of Fame is located at 2150 Richard Arrington Jr. Boulevard North, Birmingham. For information on hours and ticket prices, go to www.ashof.org or call 205-323-6665. In 2009, there were 281 inductees into the Alabama Sports Hall of Fame and 24 recipients of the Distinguished Alabama Sportsman award. To see the criteria for nominating someone for induction into the hall of fame, visit the website.

Sources

ADAH. Alabama Moments. www.alabamamoments.state.al.us.

Adams, Dean. "Interview: George Barber," September 24, 2003. www.superbikeplanet.com.

Alabama Men's Hall of Fame. Birmingham, Alabama.

Alabama Music Hall of Fame. www.alamhof.org.

Alabama Sports Hall of Fame. www.ashof.org.

Arlington Antebellum Home & Gardens. www.informationbirmingham.com.

Armbrester, Margaret England. *Samuel Ullman and "Youth": The Life, the Legacy.* Tuscaloosa: University of Alabama Press, 1993.

Barber Vintage Motorsports Museum. www.barbermuseum.org.

Bates, Ron. "Sloss Furnaces." http://facstaff.uwa.edu/ab/sloss.htm.

Bennett, James R. *Historic Birmingham and Jefferson County.* Birmingham, AL: Jefferson Historical Society/Historical Publishing Network, 2008.

SOURCES

Birmingham Civil Rights Institute. www.bcri.org.

Blakely, Hunter B., Jr. *Religion in Shoes.* Louisville, KY: John Knox Press, 1953.

The Booker T. Washington Papers. Champaign: University of Illinois Press.

Brother Bryan Mission. www.brotherbryanmission.com.

Caldwell, Henry Martin. *History of the Elyton Land Company and Birmingham, Alabama.* N.p.: Kessinger Publishing, LLC, 2009.

Carl Lewis. www.carllewis.com.

Carson, Bob. "Moretti's Warning: the Myth Demystified." *Alabama Heritage* 73 (Summer 2004).

Carver Performing Arts Center/Alabama Jazz Hall of Fame. www.jazzhall.com.

Cobbs, Elizabeth, and Petric Smith. *Long Time Coming.* Birmingham, AL: Crane Hill Publishers, 1994.

Cotman, John Walton. *Birmingham, JFK, and the Civil Rights Act of 1963: Implications for Elite Theory.* N.p.: Grove/Atlantic, 1989.

The Eleanor Roosevelt Papers, "The Tuskegee Airmen."

Encyclopedia of Alabama. www.encyclopediaofalabama.org.

ESPN: The Worldwide Leader in Sports. "Top North American Athletes of the Century." www.espn.go.com.

Fallin, Wilson. *The African American Church in Birmingham, Alabama, 1815–1963: A Shelter in the Storm.* Florence, KY: Routledge, 1997.

Hampton, Henry, Steve Fayer and Sarah Flynn. *Voices of Freedom: An Oral History of the Civil Rights Movement of the 1950s through the 1980s.* New York: Bantam, 1991.

Helms, Russell. *60 Hikes within 60 Miles.* Birmingham, AL: Menasha Ridge Press, 2007.

Sources

Interview with Bill Miller, Alabama Sports Hall of Fame, August 12, 2009.

Interview with Carol Argo, director of the Samuel Ullman Museum, April 15, 2009.

Interview with Christopher McNair. "Father Recalls Deadly Blast at Alabama Baptist Church." *All Things Considered*, National Public Radio, September 15, 2008.

Interview with David Brewer, Rickwood Field, August 11, 2009.

Interview with Jeff Ray, Barber Motorsports, August 4, 2009.

Interview with John Bryan, great-great-grandson of Brother Bryan, June 8, 2009.

Interview with Kenji Awakura, April 14, 2009.

Interview with Marilyn Raney, August 10, 2009.

Interview with Mary Moore. "Oral Histories of the American South." Southern Oral History Program, August 17, 2006.

Interview with Wayne Novy, Southern Museum of Flight, August 12, 2009.

Jet. "A.G. Gaston's Legacy is an Inspiration to Black Business Today," December 3, 2001.

Kickler, Troy L. North Carolina History Project. www.northcarolinahistory.org.

King, Dr. Martin Luther, Jr. "Letter from a Birmingham Jail." African Studies Center, University of Pennsylvania.

Lecture from Samuel Ullman delivered in 1876, Natchez, Mississippi.

National Baseball Hall of Fame and Museum. http://web.baseballhalloffame.org/index.jsp.

National Park Service. "The Tuskegee Airmen." National Park Service. www.nps.gov/archive.

National Register of Historic Places Inventory Nomination Form. Washington, D.C.: Government Printing Office.

Nunnelley, William A. *Bull Connor*. Tuscaloosa: University of Alabama Press, 1990.

Rickwood Field. www.rickwood.com

Ruffner Mountain Nature Center. www.ruffnermountain.org.

Simmons D.D. William J., Reverend. *Men of Mark: Eminent, Progressive and Rising*. G.M. Rewell, 1887.

Sixteenth Street Baptist Church. www.16thstreetbaptist.org.

Sloss Fright Furnace: Haunted House in Birmingham, Alabama. www.frightfurnace. com.

Sloss Furnaces. www.slossfurnaces.com.

Smith, Eric L. "Blazing a Trail for 100 Years." *Black Enterprise* (March 1996).

Smith, Kyle. "The Day the Children Died." *People*, August 11, 1997.

Southern Museum of Flight. www.southernmuseumofflight.org.

Southern University Press. *Green Power: The Successful Way of A.G. Gaston*. N.p.: Southern University Press, 1968.

Stocking, George. *Basing Point Pricing and Regional Development: A Case Study of the Iron and Steel Industry*. Chapel Hill: University of North Carolina Press, 1954.

Swygert, Dorothy. *A.G. Gaston: Portrait of a Dream*. N.p.: Rekindling the Heart, 1999.

United Press International. "Six Dead After Church Bombing." September 16, 1963.

Vulcan Park and Museum. www.visitvulcan.com.

Sources

War of the Rebellion. www.mycivilwar.com.

Willard, Jennifer M. "Giuseppe Moretti." *Alabama Heritage* 20 (Spring 1991).

Windham, Kathryn T. *Ghost in the Sloss Furnaces.* Birmingham, AL: Birmingham Historical Society, 1997.

Woodword, C. Vann. *Origins of the New South 1877–1913.* Baton Rouge: Louisiana State University Press, 1971.

Youth: The Life and Legacy of Samuel Ullman, documentary film directed by Judith Schaefer (n.d.).

Visit us at
www.historypress.net